In Search of the Picturesque

The English Photographs of JWG Gutch 1856/59

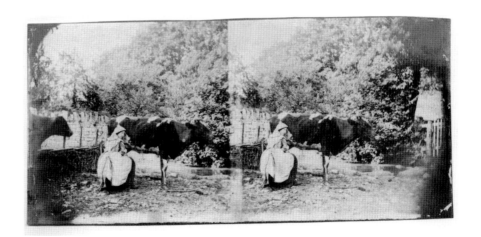

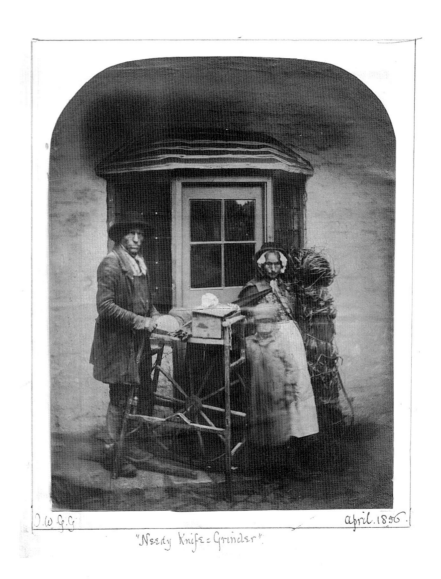

"Needy Knife = Grinder".

Needy Knife Grinder Malvern, April 1856

In Search of the Picturesque

The English Photographs of JWG Gutch 1856/59

Ian Charles Sumner

WESTCLIFFE
BOOKS

For my parents, Roy and Lilian Sumner, and with thanks to my
wife Marjorie and son Patrick, for their patience.

First published in 2010 by Westcliffe Books, an imprint of Redcliffe Press, 81g Pembroke Road Bristol BS8 3EA

www.redcliffepress.co.uk

© Text Ian Charles Sumner

ISBN 978-1-906593-27-8

British Library Cataloguing-in-Publication Data

A catalogue record for this book is available from the British Library.

Design and production: Stephen Morris www.stephen-morris.co.uk smc@freeuk.com

Printed and bound in the Czech Republic by Akcent Media

Contents

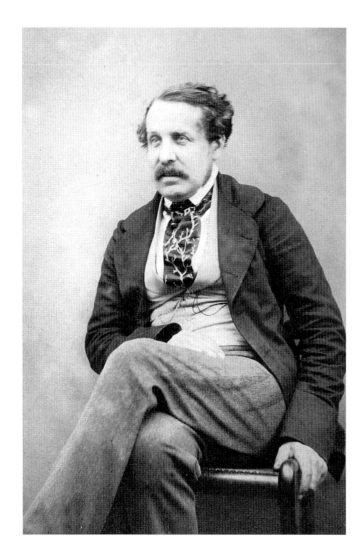

John Wheeley Gough Gutch (1808-1862) c.1855.
Photographer: John Gregory Crace (1809-1889).
Half-plate albumen print from collodion negative.
Courtesy of The J. Paul Getty Museum, Los Angeles, California.

Preface

John Wheeley Gough Gutch was born in Bristol in south west England on Christmas Eve 1808, was trained as a surgeon there and practised as a physician in Florence, Swansea and London. In the 1840s he quit medicine and became a Queen's Messenger and the editor of a scientific annual. He had a wide range of interests that included geology, botany, entomology, meteorology and photography. He was experimenting with making photographs as early as 1841, just two years after William Henry Fox Talbot announced his discovery.

He was particularly active in photography during the mid- and late-1850s and was perhaps unique amongst early photographers in making comprehensive records of a variety of particular locations in Britain. He photographed in Worcestershire, Somerset, Cornwall, Gloucestershire, Devon, Cumberland, Scotland and Wales, often spending weeks or months in one area. He bravely attempted to photograph every church in Bristol and Gloucestershire in 1858-59.

My first connection with his work came in 2001 when I purchased an 1850s salt-print photograph showing a woman standing in an orchard holding a parasol, with an ancient building beyond. The location was Woodspring Priory near Weston-super-Mare in Somerset. I knew the spot, it was the first location that I had photographed for The Landmark Trust, a charity that restores and maintains unusual and often ancient buildings. The photograph was modest in size and by a competent amateur; later I discovered that it was by Gutch.

The following year a friend, Richard Meara, showed me a list of miscellaneous photography lots that were appearing at auction in the forthcoming couple of weeks. Amongst the run of the mill *carte de visite* albums was one lot that appeared interesting: six albums of photographs showing scenes in the Lake District, Malvern and Devon. The Midlands auction house had dated them as 1956; this suggested family snapshot albums, less than fifty years old and of little or no interest. I suggested that Richard should follow them up, the date might be incorrect. It turned out that the date was 1856; a hundred years adrift.

There was no name on the modestly-sized, slim, soft-cover albums, just the distinctive initials JWGG. I realised that the photographer was John Wheeley Gough Gutch and I knew that several albums of his work had appeared at London photography auctions, mostly in the 1980s and '90s. I decided to do some research and discovered that about twenty of his albums were known to exist, several of them in American collections.

Further research into John Gutch's life led me to discover that his antecedents had lived in Glastonbury and Wells in Somerset; this gave me a local interest as I too had lived in both these towns, albeit some 300 years later.

I found the photographs in the six recently-discovered albums fascinating; all the 'whole-plate' (16.5cm x 21.5cm) prints were titled, initialled and dated, and each formed a record of a particular area, almost in a photo-journalistic manner. The photographs appealed to me on several levels; the varied subject matter, the fact that they had survived for over 150 years and the obvious trouble that Gutch had gone to, not only to make the photographs, but in creating the individual albums that invariably contain poetic quotes and photographic collages that were made from 'contact-prints' of leaves, and occasionally feathers. These were personal creations, carefully considered and containing photographs that, at their best, rivalled work by fellow photographers Roger Fenton or Benjamin Brecknell Turner, although on a much more modest scale.

The two earliest albums are dated 1856 and show views of the genteel spa town of Malvern and surrounding area, along with a few portrait studies. They were made over a period of several weeks and it was apparent that Gutch was combining both making photographs and having treatment at a 'hydropathic establishment' for his long-standing gout and kidney complaint.

In his writings Gutch indicates that his photography was both a search for 'health and happiness' and 'The Picturesque'. Like many artists and photographers of the period the picturesque decay of ancient buildings and their associations with the past were a major appeal during the rise of the Industrial Revolution, when change was happening at an unprecedented rate. Canals and railways

had changed Victorian Britain, opening up areas of the country to the middle classes, allowing them to visit places that they had previously only been able to read about. Paradoxically the rapid changes occurring to the country-side were the very ones that now allowed tourists to visit areas like the Lake District. In common with most artists Gutch ignored the squalor of the city slums. Rustic locals in the countryside were another matter; despite living in poverty they retained their dignity. Gutch was in a sympathetic mood when he made his study *A Needy Knife-Grinder* at Malvern in 1856. Gutch made some equally sensitive studies of young miners and traditional fishermen in Cornwall two years later.

The Malvern albums contain several lines of poetry, along with quotes from books by local authors, which often provided Gutch with inspiration for his subject matter. An ancient elm tree mentioned by writer Edwin Lees was significant enough to Gutch to warrant at least two negatives. No other photographers working at this period seem so influenced by the written word. Although the chosen location and subject matter of Gutch's photographs were often dictated by writers and poets, his picture titles were nearly always matter-of-fact and only a very few early portrait study captions stray towards sentimentality.

The titles given beneath the images can sometimes cause confusion as different photographs taken in one general location may have the same title. Furthermore, the same image may have several titles in other albums, or on

his contemporary printed lists. For the same reason it is often not clear from exhibition titles which precise images were shown by Gutch in the late 1850s. Unmounted prints can provide further problems as they are very rarely identified on the reverse. The photographs offered for sale at exhibition and through print sellers in Cornwall and Bristol were generally mounted on card or placed in 'drawing book albums' with the titles written beneath in Gutch's distinctive hand. The title and the spellings used in the captions are as written by Gutch in the albums from which the images are reproduced. Occasionally I have used my own judgement to describe the image if it is not captioned.

I have not generally described the particular views depicted in Gutch's photographs; many of the scenes and buildings have long ago disappeared and I have not attempted to revisit or re-photograph the locations. All the prints reproduced are at least 150 years old and many show the passage of time, some faded, creased, torn and foxed. The plates have been retouched to remove marks or defects and many have increased contrast to provide a better illustration of perhaps how the original print appeared a century and a half ago. Photographers at this period, including Gutch, used a wide variety of processing techniques to produce their prints; the type of paper, the chemicals used in development and toning, the fixing process and the amount of washing all affected image tone, colour and permanence.

The photographs reproduced in this volume are mainly drawn from the albums and loose prints in the collections of Richard Meara, the Wilson Centre of Photography and the author. The emphasis is on Gutch's view of England and virtually none of the photographs have ever been reproduced previously.

I would like to thank Richard Meara and Michael G. Wilson for kindly allowing me to reproduce work from their collections. Also Julian Cox, Andrew Farmer, Christopher Gutch, Ken Jacobson, Rev Nigel Nicholson, Jeanette Rosing, Roger Watson and John Winstone for their help and support.

Ian Sumner. Pilton, Somerset, February 2010

The Photography of JWG Gutch in Context

Richard Meara

'Making the Dry Bones Live'

In considering the activities of those who took up photography in the early years it is easy to forget how exciting their work must have been to them. Some of the early practitioners who chose to write about their craft seemed determined to emphasise its hardships and dangers; perhaps not surprising given that so much could go wrong before, during and after the photographic act. John Forbes White (1831-1904) was a close friend of the pioneering Scottish photographer Dr Thomas Keith, and was also, like him, an accomplished calotypist. They photographed both together and separately during the 1850s, using waxed paper negatives and salted paper prints. White's home was in Aberdeen and he photographed much in his local area. But he also travelled further afield in Scotland, England and Wales to take photographs. His daughter, Ina Mary Harrower, in a biography of her father written in 1918 described how 'during all his full life travel was an undiluted joy to J.F. His spirit rose as soon as he got into a railway carriage.'

Photographers at this period would also have felt the elation of possessing a skill few others possessed, one that could appear to uninitiated observers both magical and, in the hands of an experienced practitioner, facile and speedy. As they set up their wooden cameras onlookers would gather, unsure whether to watch or to try to be included in the picture. The 1850s were a transitional period between the gentleman amateurs of the very early years of photography on paper and the professional group of operators who began to produce their work in book and folio form, or to sell prints through commercial outlets such as stationers.

It is possible to see all these factors reflected in the work of John Wheeley Gough Gutch. In spite of infirmity he travelled a great deal in England, Wales and Scotland, and it is reasonable to assume that he enjoyed his peregrinations. He undoubtedly used the burgeoning rail network and included evidence of it in some of his photographs. It is notable that local people, often children, frequently appear in his photographs of architecture and landscape. Were these local urchins who pushed their way into the picture regardless? Gutch does indeed make a reference to being irritated by their presence in the articles he wrote about his travels for *Photographic Notes*. But human figures appear so frequently as to suggest that he deliberately included them, both to give scale, and to humanise the landscape. An article in May 1864 in *The Photographic News*, another specialist publication, stated:

The landscape photograph is beautiful, but we look at it and pass it by having no associations ... But think of our ancient buildings. How easily ... can we make the dry bones live.

Gutch made them live in part by giving them social context, thus drawing the viewer of the photograph away from contemplation solely on the picturesque ruin. Nevertheless the picturesque, as expressed in 'crumbling castles and tottering mansions' was of overwhelming interest to the Victorian mind, and Gutch must have been influenced by it.

A number of concepts would have been constantly in the minds of Victorians with an artistic or literary leaning, including many of those who took up photography. 'The Picturesque' as an artistic theory had been devised by the Revd William Gilpin in a series of books beginning with *Observations Relative Chiefly to Picturesque Beauty made in the year 1772*. The concept may seem to later eyes rather vague but its formal characteristics were concerned with line and chiaroscuro (light and shade); with irregularity and variety of texture; with the use of dark foregrounds to set off the distant view; and this could readily be found in the roughness and unevenness associated with old buildings and with ruins. Gilpin was so taken with his theory that many of his illustrations of actual 'picturesque' locations bore little resemblance to the reality. 'I am so attached to my picturesque rules that if nature gets it wrong, I cannot help putting her right.'

This approach seems so contrary to the essence of photography, at least until today's digital era, that it seems paradoxical that it influenced the approach of mid-Victorian photographers. However, by then the concept had become inextricably linked with another idea, that of the 'Romantic'. From the early nineteenth century the term 'romantic' had been defined, by Madame de Stael, as a form of modernism. To be a romantic meant that you were courageously facing the realities of the age. The 'classical' style led to work that dwelt on formal values; whereas the 'romantic' style led to art that emphasised the imaginative and associative side. Hence the focus on ancient ruins, old trees, waterfalls and mountains, all of which were riddled with meaning both for the Victorian photographers and for their audience.

William Wordsworth and his fellow romantic poets Samuel Taylor Coleridge and Robert Southey were familiar with Gilpin's theories and in sympathy with them. To these theories they added their own belief in the associative quality of architecture and landscape. To them trees and ruins communicated specific emotions and moral feelings. In his poem *The Tables Turned* Wordsworth wrote:

One impulse from a vernal wood
May teach you more of man;
Of moral evil and of good
Than all the sages can.

These were radical thoughts for their time, and suited the radical natures of Southey and Coleridge who at one stage

wanted to set up a communistic society in America. Thus as Roger Taylor remarks in *Impressed by Light*:

> By the 1850s the Picturesque was no longer simply a fashionable aesthetic, but had become the overarching language through which nature was appreciated, informing visual preferences for an entire generation of photographers and their audiences.

Gutch applied this language in his photographs of ancient oaks, country lanes, venerable ruins and dilapidated buildings. Indeed it is clear that he held Southey in particular regard. A photograph of his tomb in Crosthwaite churchyard is included in an album of Lake District photographs dated 1857. On the page opposite the photograph Gutch has written out in full the inscription on Southey's tomb, and he includes three further photographs relating to Southey in the album. A second album of Lake District photographs includes salt prints of the tombs of Wordsworth and Coleridge at Grasmere. The inclusion of poems by Sir Walter Scott penned by Gutch's own hand gives these exquisitely wrought albums the quality of a hymn to the mystical and romantic nature of Lakeland.

Gutch was, however, not just dealing with established aesthetic notions and theories. He was using a new medium which brought its own way of seeing, and also its own technical challenges. He used wet collodion on glass negatives, a process invented in the early 1850s by Frederick Scott Archer. In the early 1850s he had used the paper negative process, but the overwhelming majority of his extant work uses the glass negative. It is likely that he did so because of the unusual camera he chose to adopt. This was a specialist device which allowed him to manipulate and actually develop the negative while it was still inside the camera. Indeed there is evidence that it was the availability of this camera that encouraged him to take up landscape and topographical photography in earnest and led to the flowering of his talent in the mid-1850s.

Because of this he turned his back on the paper negative, the favourite of the gentleman amateurs who regarded its ability to convey light and shadow, mass and mystery in a more painterly way as essential to their view of photography's place in the artistic canon. Gutch did, however, continue to use the salt print as a key element of his technique and aesthetic. He used both salted paper prints and a transitional paper, sometimes called dilute albumen or albumenised salt, which was common prior to the introduction of the full albumen print from the 1860s onwards. The salt print and the dilute albumen print offered a matt surface in which the image seemed more to sit in the texture of the paper rather than within the thin layer of albumen on top. These papers undoubtedly were better suited to the picturesque and romantic elements which infuse his prints and albums.

How did Gutch's practice compare to that of his contemporaries? His work was undoubtedly more intimate in size and presentation than some of the photographers who worked in the 1850s. Some like Dr

Thomas Keith in Scotland and Joseph Vigier in France continued to use the paper negative process and to print on to salted paper. Vigier, who photographed in the Pyrenees in 1853, used particularly large negatives, as did his fellow Frenchmen Edouard Baldus and Gustav Le Gray. All produced images of impressive monumentality, in many cases designed to be exhibited and to possess what today would be called 'wall power'. English exponents of this approach at the same time included Roger Fenton, who took his large-format camera to the established picturesque locations and produced some of the most impressive landscape work of the nineteenth century, and Benjamin Brecknell Turner who used both salt and albumen prints in large format and offered them in self-consciously ostentatious display. He produced an album of 60 large prints taken in 1852-54 (now in the Victoria and Albert Museum) – a specially created volume of elephant folio proportions – as 'an anthology for considered public scrutiny' in the words of Mark Haworth-Booth. Turner's enthusiasm had been fired by the displays of photography in the 1851 Great Exhibition, and by the exhibition of 'Recent Specimens of Photography' that followed it in December 1852. Roger Fenton in the catalogue of this exhibition wrote of English photography:

> excelling in depictions of the peaceful village; the unassuming church among its tombstones and trees; the gnarled oak standing alone in the forest; intricate mazes of tangled wood; the still lake ...

Gutch's work is very much in this tradition, although in a less grandiose and more intimate way. Yet it is also possible to see in his photographs a different, peculiar and more personal vision, one drawing on the established canon, but with a distinctive edge. So what distinguishes Gutch from his contemporaries? Firstly his disability: he suffered from severe gout which left him with residual disability down one side and he needed a walking stick to get around. Not only does this impairment make his achievements with the camera all the more remarkable, but it is reflected in some of his subject matter. He devoted two of his albums to views of Malvern and vicinity, a spa town where a number of well-known physicians used the waters in various forms of hydrotherapy. Gutch quotes from Dr Booker's *Malvern* in a hand-written poem as part of the frontispiece to the first album:

> O hither come the bracing air to breathe,
> The hallowed lymph to drink; or lave thy frame,
> Nature reviving, in the crystal stream.

One of the pre-eminent physicians was Dr Gully, who most probably treated Gutch, and whose house features in a number of prints in the album. Other prints show the douche baths, Dr Wilson's hydropathic establishment, St Ann's well and the home of Dr Stevens, who was the originator of the saline treatment for cholera. The first album concludes with two delightful portraits of *W. Groves, My*

Bathman.

In *Impressed by Light* Roger Taylor points out how fearful the Victorians were of disease, and how they came to see the cities as unhealthy, and the country and seaside as restorative. As he puts it, 'the curative powers of landscape merged with the idea of the Picturesque.' Gutch's Malvern albums can be seen as homage to the healing powers of the town and its surrounding countryside.

Another peculiarity of his practice is how frequently he places himself in his photographs. Time after time the same figure appears facing the camera, leaning on his stick, sometimes slightly concealed in shadow, but more often a deliberate component of the picture. Contemporary photographers occasionally included themselves in the frame in order to provide scale, but not with the frequency adopted by Gutch. It is intriguing to speculate why he placed such importance on positioning himself in the landscapes he photographed.

It has often been remarked that photographers of this period went out of their way to exclude evidence of the Victorian industrial world in their work. Factories and railways almost never appear. Gutch is again a notable exception. In a relatively small album titled *Tintern and Chepstow 1856* containing 11 prints there are two photographs of the New Iron Bridge Chepstow, and the Tubular Railway Bridge Chepstow. Both were new constructions, the great tubular bridge over the river Wye having been built by Isambard Kingdom Brunel in 1852. They deliberately intrude between traditionally picturesque views of Tintern Abbey and Chepstow Castle. In the second of his albums of Lake District views he includes prints of the Black Lead Pencil Manufactory at Keswick and Mr Bankes' Pencil Manufactory from Greta Hall, as well as a view of a tanyard at Keswick.

Unlike many of his contemporaries Gutch also chose to include social portraits in his architectural and landscape work. The Somerset and Cornwall album of 1858 is notable for some striking portraits of people in their native setting, including Pilchard Fishermen; Boatman, St Michael's Mount; Fish Boy, Idearn; Group of Miners at Levant Mine; and Fishermen, Porthgwarrah Cove. One of the Lake District albums includes what would now be called social documentary photography, depicting a Group of Children at Grange Bridge, and Men in Quayfoot Slate Quarry.

In this, Gutch moved beyond contemporary practice to establish his own photographic style and vision that recognised current idioms but also anticipated an almost twentieth-century approach to the art of photography.

The final peculiarity of Gutch's practice is the delightful way in which he put together the albums. They are meticulously hand-crafted, very different from the grand albums being assembled by some of his contemporaries. Most have soft red-linen covers, with a small rectangular printed slip of paper in the centre, containing space for the title. Introductory pages are decorated with photogram collages of leaves that have been cut out around their outline and assembled in attractive patterns, sometimes

surrounding a verse of poetry. Interspersed with the photographs are extracts of poetry that Gutch thought related to the subject matter. At times the photogram collages of leaves are used as punctuation marks, to indicate different sections of the album. In most albums each print is titled below in Gutch's own hand, and many are initialled 'JWGG' below the bottom right-hand corner.

Each must have been a labour of love, hand-crafted by the photographer, possibly for himself alone, or perhaps as a commission for an important client or friend. It is known that he offered his prints for sale through stationers in Bristol and Cornwall and that he exhibited his work in Edinburgh at the Photographic Society of Scotland as well as in London at the Architectural Photographic Association and the Photographic Society. But there is no evidence that he operated on a wider commercial level. A surprising number, in excess of 20, of his albums have survived, but the majority seem to be personal rather than commercial productions, set apart from the prints he allowed to be sold on an individual basis, preserved to remind himself of his photographic odyssey.

John Ruskin, the great mid-Victorian art critic, who regarded photography as no more than a mechanical medium, pronounced:

Whatever the photographer's skill with the glass vial or the painter's with the camel's hair brush, the production of neither photograph nor painting was true art unless 'the inner part of man' had stood forth and declared 'Behold, it is I'.

In both his photographs and his presentation of them John Wheeley Gough Gutch fully lived up to this tenet.

1 Family History

John Wheeley Gough Gutch was descended from an old south Wiltshire family and early records show that a 'Mr. & Mrs. Guche' married in 1503, probably in the village of Tisbury, close to the cathedral city of Salisbury.

The spelling of the unusual family name changed considerably from the earliest parish records of the late-fifteenth century; more than a score of variations appeared until it settled into the accepted form of Gutch at the start of the nineteenth century. The derivation of the word 'guche' or 'gutche' has been attributed to the Old English word for a pot-bellied jug. At Semley, close to Tisbury, the name survives at Gutch Common. A pond once there, supposedly in the shape of a jug, is one possible explanation given by a descendant, Wilfrid Gutch, who undertook family research in the 1940s. John Gutch himself was interested in his family history; in the 1830s he recorded inscriptions on family members' gravestones in Oxford, Birmingham and Swansea.

Mr. and Mrs. Guche's son, Clement (1504-1563), married an unknown woman at Tisbury in 1533 and a son, named John, was born a year later. Following the death of the child's mother, Clement later married a widow named Elizabeth Snowe. In 1555 Clement's son John (1534-1572) married Agnes (1537-1616), who produced four sons and two daughters. Clement, on his death in 1563, bequeathed a shilling to the poor of the parish and the same to the local curate, William Mosley. His family fared slightly better; the sons each receiving a sheep and the two daughters a lamb.

In 1568 Agnes gave birth to a son also named John at Tisbury. Around thirty years later John, his mother Agnes and two of his brothers moved from Wiltshire to neighbouring Somerset. They all settled in or around the ancient town of Glastonbury, whose large and wealthy abbey had been plundered during the dissolution of the monasteries 30 years earlier. The Gutch brothers all appeared to prosper in Somerset and became successful local merchants and land owners. Robert Gutch, a young nephew of John, thought he would make his own fortune in America and left Glastonbury in about 1637, aged 20, to become one of the first settlers in Salem, New England. He later moved to Maine, and in 1660 purchased 4,000 acres from five Indian chiefs or sagamores, the leader of whom was known as 'Ramegin' or 'Robin Hood'. The Reverend Robert Gutch became known as 'preacher to the fishermen' at Kennebec, near Bath, Maine, where he drowned in 1667. He was the first known member of the Gutch family to become a minister.

Following the move to Somerset John Gutch (1568-1646) had become wealthy, owning several properties in Glastonbury and Wells, along with land in Dorset and Devon. By 1630 he is recorded as a yeoman and churchwarden living at Chelwood, a hamlet situated between Wells and Bristol in north Somerset. John's first wife, Avis, died in 1635 and a year later, aged 67, he married his second

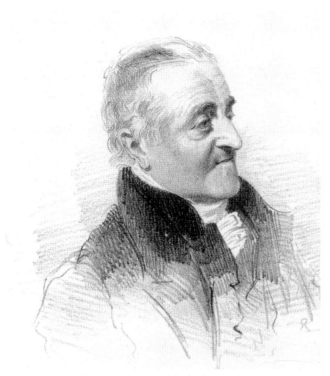

The Revd John Gutch, Registrar of Oxford University

Elizabeth Gutch, wife of Revd John Gutch

wife, Barbara Goodale. Age didn't stop him fathering at least four children including Robert, their youngest son, born at the start of the English Civil War in 1642. John, his father, passed away just four years later.

Robert Gutch (1642-1684) became a mercer (silk merchant) at nearby Wells, the smallest city in England, and married Flora Thirlby some time before 1675. He lived at Ivy Hall in Chamberlain Street and died in the city in 1684. His wife died almost 60 years later. His son, also named Robert (JWGG's great-great-grandfather), was

born soon after he married Jane Prickman at the city's medieval cathedral. Like his father, Robert was a wealthy merchant; he also became a burgess of the city. He died in his early fifties in 1727, his wife Jane some 15 years later.

Robert and Jane's son, John (great-grandfather to JWGG), was born at Wells on 10 September 1705. He was a very busy man; serving as town clerk in the Somerset city for thirty years from 1741-72. He was also a respected solicitor at London's Serjeants' Inn; was Master of the Tailors' Company and Steward to the Vicars' Choral in Wells. He

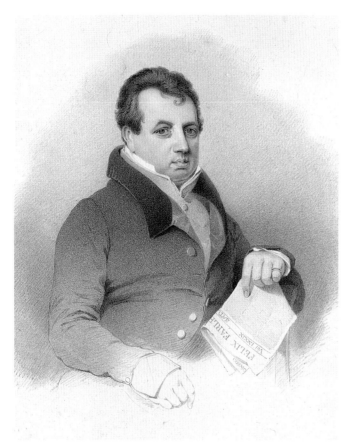

John Mathew Gutch with a copy of *Felix Farley's Bristol Journal*

Oxford University's Registrar from 1797-1824 along with holding several other scholarly and clerical positions. The *Dictionary of National Biography* described him as: 'popular, small in stature, courteous and suave with a gentle disposition, negligent about money matters and ever ready to help fellow antiquaries'. He married Elizabeth Weller (1753-1799) in May 1775 and they produced six sons and six daughters, nine of whom survived into adulthood.

The eldest son, John Mathew (JWGG's father), was born at Oxford on 22 March 1776. His father, the Reverend John Gutch, died at Oxford on 1 July 1831 aged 86.

John Mathew Gutch (1776-1861) was educated at Christ's Hospital school in London along with the poet Samuel Taylor Coleridge (1772-1834) and essayist Charles Lamb (1775-1834).

Shortly before 1800 John Mathew Gutch became a partner in the firm of Anderson and Gutch, a stationery business that supplied legal documents to solicitors at the nearby Inns of Court from their offices and apartments at 27, Southampton Buildings.

In May 1800 the eccentric Charles Lamb and his sister, Mary, who in 1796 had killed their mother in a fit of insanity, moved into Gutch's apartments at Southampton Buildings and lodged with him for nearly a year. While he was staying with his former school friend Lamb made up a story about money being stolen from Gutch's stationery business. He also poked gentle fun at his friend's impending marriage to the daughter of a 'mere' (but seemingly wealthy) coach builder. It is not clear whether Gutch

managed to find time in February 1743 to marry Mary Mathew (1712-1765) at Shaftesbury in Dorset.

Their son, also named John (JWGG's grandfather), was born in Wells on 10 January 1745. He attended Oxford University and matriculated from All Souls College in 1765, was ordained in 1768 and shortly afterwards became Chaplain of All Souls, a post he held for over sixty years. He was

appreciated Lamb's odd sense of humour. Despite the teasing, John Mathew went ahead and married Mary Wheeley in Birmingham on 15 October 1801. Not surprisingly Charles Lamb and his notorious sister had already moved out of JMG's apartments some months earlier.

Mary Gutch gave birth in September 1803 to the first of the two boys that were to be named John Wheeley. John Mathew Gutch proudly wrote to his brother Robert on the day of the birth and described the baby as having a full head of black hair; sadly the infant survived only a few days or weeks. The second surviving son with the same name was to be born five years later. They also had at least one daughter, who may also have died in infancy. Many years later John Mathew grieved for her in his book of verse, *The Old Oaken Chair,* published in 1850.

In September 1805 John Mathew Gutch formally became the proprietor of the weekly *Felix Farley's Bristol Journal.* The journal's founder John Broughton Rudhall had recently died and his widow Henrietta 'assigned the newspaper's copyright' to JMG in recognition of the sum of £1,800. It appears that the new venture was funded by JMG's father-in-law, Francis Wheeley, the coach maker from Birmingham.

It must have been around this date that JMG moved from London to Bristol to run his newspaper, funded by his generous father-in-law. John Mathew Gutch remained the owner, editor and publisher of the often controversial publication until 1844.

John and Mary Gutch's only child to survive to adulthood was born on Christmas Eve 1808 at Kingsdown in Bristol and given the name of his late brother, John Wheeley Gutch. The parents followed the family tradition in naming the first son after the father and giving the middle name Wheeley after the maternal grandparents. The name Gough was added later, in recognition of his grandfather's lately deceased friend and fellow antiquary, Richard Gough (1735-1809). The child was christened by his grandfather the Rev John Gutch at Oxford on 4 July 1809.

John Mathew Gutch became a member of Bristol's busy literary and artistic circle that included the poets Coleridge and Robert Southey (1774-1843). Other figures associated with the West Country literary scene and known to JMG included the poet William Wordsworth (1770-1850), the opium-eating author Thomas de Quincey (1785-1859), and writers Revd John Eagles (1783-1855) and Maria Edgeworth (1767-1849).

Bristol had been a magnet for scientists, artists, poets and dreamers since the end of the eighteenth century. Dr Thomas Beddoes (1760-1808) had set up the Pneumatic Institute at Clifton, where at one time Humphry Davy (1778-1829) was the laboratory superintendent. Another influential figure was Dr John King (1766-1846), a German-born surgeon, liberal patron of the arts and book collector who worked at Beddoes' Institute and who was also a friend of Coleridge, Southey and Davy.

In 1817 John Mathew Gutch, by then a noted journalist, wrote and printed the extraordinary story of an impostor,

Richard Gough

the self-styled 'Caraboo, Princess of Java'. The episode concerned a young woman who pitched up at Almondsbury near Bristol claiming to be an exotic eastern princess. She was taken to nearby Knole Park, where a multi-lingual manservant was called for to interrogate the stranger. This

unlikely but true tale was recorded in book form by JMG: *Caraboo: A Narrative of Singular Imposition.*

A patron of the arts as well as a publisher and author, John Mathew Gutch collected antiquarian books and manuscripts and at one time owned Coleridge's commonplace book. Evans of Pall Mall sold a large collection of his books in January 1817 for £420 and 41 years later, after he had been made bankrupt, a further valuable collection was auctioned by Sotheby and Wilkinson over several days for a total of £1800.

John Mathew Gutch's wife Mary died at Bristol in 1822 and was buried at Redland Chapel, near the family home at Beaufort Lodge that had become a meeting place for the local literary set. The following year he married Mary Lavender, the daughter of wealthy Worcester banker John Pearkes Lavender and joined him as a partner in his banking business. Following his second marriage he moved to Common Hill at Claines near Worcester; the 1841 census shows him living there in some style with his wife and four servants, although he regularly travelled back to Bristol to edit *Felix Farley.*

In 1828 John Mathew Gutch became involved in another publishing business; along with Robert Alexander he helped found *The London Morning Journal.* It was a disastrous, short-lived venture and only a year later they found themselves sued by King George IV and his Chancellor, Lord Lyndhurst (1772-1863), for a supposed libel on the Duke of Wellington (1769-1852), then prime minister.

The subsequent three-day trial, held shortly before

Christmas 1829, was reported extensively in *The Times*. The outcome was predictable: Gutch and his fellow defendants were found guilty and the fledgling newspaper suppressed. The editor, Robert Alexander, was fined £101 and sent to Newgate Prison for four months. The trial ruined JMG financially; his unsuccessful but expensive defence had been conducted by Jonathan Frederick Pollock (1783-1870). Sir Frederick later became the second President of the Photographic Society, replacing Sir Charles Eastlake in the mid-1850s.

Like his father before him, John Mathew Gutch seemed to have little idea of managing money. His 1829 court case and subsequent closure of *The Morning Journal* had been ruinous. Yet more financial worries were to follow; Gutch was a partner in his late father-in-law John Lavender's 'Farley, Lavender and Owen' Worcester bank. It failed after 60 years in business and JMG was declared bankrupt at the age of 82. *The Banker's Magazine* of 1858 carried a brief report of the bank's demise. By the time of his death, at Barbourne near Worcester on 27 September 1861, his estate was valued at 'less than £20'.

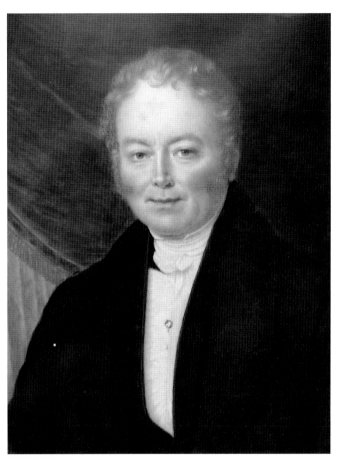

John Pearkes Lavender

2 Florence and Swansea

'To hold as it were the Mirror up to Nature'
William Shakespeare

John Wheeley Gough Gutch was born in Bristol on 24 December 1808, just a few years after his parents' move to the busy West Country port from London. Following the death of his mother in 1822, he was educated as a surgeon at the Bristol Royal Infirmary, a charitable trust established in 1737 with donations from local philanthropists. His family would have sponsored him to train there during the mid- and late 1820s, a time when more than nine hundred charitable subscribers supported the hospital, which housed almost two thousand in-patients, and treated double that number of out-patients.

Gutch was granted membership of the Royal College of Surgeons (MRCSL) in 1831, aged 22. This was the same year that bloody riots hit his home city; the Bristol Riots took place over two days at the end of October 1831 and were part of the general unrest prior to The Great Reform Act of 1832. The destruction was the worst seen in England during the nineteenth century and was recorded in an exceptional series of paintings by Bristol artist W J Muller (1812-1845), as well as being extensively reported by John Mathew Gutch in *Felix Farley's Bristol Journal*.

The newly qualified doctor had left England for the Continent in early 1831, well before the riots in October. In July he was sketching by the banks of Lake Geneva on his way to Florence, where he was due to be employed as a private physician. Gutch would have been keen to secure a well-paid job; his father had been involved in an expensive libel trial just two years earlier and was no doubt unwilling or unable to finance his son's Continental journey. The young Gutch had travelled overseas earlier than 1831; the album *Sketches on the Continent 1828-1835* indicates at least one previous visit, although no foreign sketches survive from before 1831.

On 12 December 1832, after a year as a physician in Italy, John Gutch married 20-year-old Elizabeth Frances Nicholson at Florence. His Belfast-born wife was the daughter of Irish Quaker Robert Jaffray Nicholson (1768-1841) who lived with his family in the Tuscan city. The following November Elizabeth gave birth to a son they named John Frederick Lavender Gutch. An eagerness to mark John Mathew's return to financial stability (he became a partner in his wife's family's bank) was almost certainly one reason behind adding JWGG's step-mother's maiden name when the baby was baptised at Florence on 5 December 1833.

The young couple lived at Villa Pace, not far from the observatory that was then being constructed and which JWGG recorded in a pencil drawing. During his time in Italy Gutch made a series of sketches with the help of a *camera lucida*, a portable drawing aid. Fellow frustrated artist and the inventor of modern photography, William

Henry Fox Talbot (1800-1877), had used a *camera obscura* in Italy in the 1820s. Later, he also used a *camera lucida* to help him record the Italian lakes during his honeymoon in 1833. It was his weak attempts to create half-decent drawings with these aids that led him to start his experiments into photography the following year.

The *camera lucida* had been invented in 1806 by the scientist William Hyde Wollaston (1766-1828). Despite its name the instrument was not a camera at all in the accepted sense. Most designs consisted of a thin brass adjustable tube with a clamp at the bottom and an articulated prism at the other end. The device helped artists transpose the image they saw through the prism on to the page of a sketchbook. It was not particularly easy to use, although it was very light and portable, folding up into a shallow fitted-leather case which slipped into the pocket.

Both the Gutch and Nicholson families left Italy and returned to England in April 1835. Gutch, his young wife and baby briefly returned to London; the Nicholsons moved to Stoke Damerel, Devonport, near Plymouth in Devon. After visiting both his uncle in Paddington and father near Worcester, the next we know of Gutch and his family is when they are at 27, Wynd [Wind] Street in Swansea, South Wales, where he practised as a surgeon. It is unclear why Gutch moved to Swansea, although he may have been attracted by a seaside climate which would have been far healthier for their delicate son than London.

The Swansea climate and Gutch's skill as a physician did little to help their only child, however. He died on 21

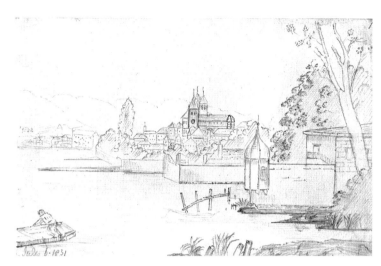

Sketch of Lake Geneva by JWG Gutch

March 1838, aged four years and four months. The child was buried in the churchyard of All Saints church that overlooks the beautiful bay at Oystermouth in Mumbles, just along the coast from Swansea. The gravestone carried the following epitaph, probably penned by JWGG himself:

> E're sin could blight or sorrow fade
> Death came with friendly care
> The opening bud to Heaven conveyed
> And bade it blossom there

In 1854 or 1855, during one of his return visits to Swansea, JWGG made a study of the church at Oystermouth. The simple, plain building was recorded in a strong, simple image as a memory of his lost child. (National Trust Collection, Lacock.)

Gutch collected plants and insects in and around Swansea and the Gower Peninsula, including coleopterae (winged beetles) which held a special interest. He became a member of the Meteorological Society and edited their journal. He was elected a fellow of the Linnaean Society and became an early member and honorary secretary of the Swansea Philosophical and Literary Society (founded in 1835).

In South Wales Gutch became a close friend of Lewis Weston Dillwyn (1778-1855), a naturalist and manager of the Cambrian Pottery who lived at Penllergaer. Dillwyn had been high sheriff of Glamorgan in 1818 and Member of Parliament for Swansea in both 1832 and 1835. He also became the first President of the Swansea Philosophical and Literary Society, later known as the Royal Institution of South Wales. Dillwyn had married Mary Llewelyn in 1807 and their son, John Dillwyn, was born three years later. He added his mother's maiden name to his surname in 1832, becoming John Dillwyn Llewelyn (1810-1882). He is often known as the 'first photographer in Wales', although there are several other contenders for this title, including Calvert Richard Jones (1802-1877), who was a neighbour of Llewelyn's at Penllergaer.

In Swansea JWGG managed to immerse himself in a host of scientific pursuits. Interested in meteorology, he maintained a tide-gauge and corresponded with astronomer royal George Biddell Airy (1801-1892). He kept extensive meteorological records of the local temperatures, rainfall levels, wind directions and full descriptions of the weather conditions from 1836 until he left the city. He kept an open house at his home in Wynd Street, where in 1838 he experimented with an 'atometer': 'An instrument highly valuable for ascertaining the amount of evaporation upon the Earth's surface'. The Philosophical Society's annual report of 1838 further stated that:

> It [the atometer] is erected on the premises of Mr Gutch, who, with his usual urbanity, permits the inspection of it by any member of the Institution.

Gutch was generous with his time and keen to share his knowledge with fellow members of the Institute. He was curator of the society's collection of entomology and botany, delivered detailed papers on the history of bees and silk worms, lectured on the physiology of insects and donated 100 specimen plants, all collected in the South Wales district.

Swansea was the home of several wealthy landowners and civic leaders interested in the scientific advances of the early nineteenth century, many of whom later became noted photographers. The wealthiest of these was Christopher Rice Mansel Talbot (1803-1890). Kit Talbot was a cousin of Fox Talbot and would have been one of the first to hear of Talbot's process of photography in early 1839. William Henry Fox Talbot made his announcement of The Art of Photogenic Drawing in January 1839. As honorary secretary of the Swansea Philosophical Society Gutch would have been immediately interested in its possibilities.

Along with meteorology and botany, geology provided a further fascination for Gutch. Eminent geologist Henry Thomas de la Beche (1796-1855) was a frequent visitor to South Wales and in 1838 the son of Gutch's friend, Lewis Weston Dillwyn (also named Lewis), married the famous geologist's daughter, Elizabeth. In company with Henry de la Beche and several local worthies JWGG is reported to have explored the Spiritsail Tor Cave at Llanmadoc on the Gower peninsula in 1839. The party discovered hyena bones and rhinoceros teeth, along with many fossils in the cave and Gutch supposedly provided a photograph of their visit. (Cox: *From Swansea to the Menai Straits; towards a history of photography in Wales*)

Assuming the date of 1839 is correct, this would have meant making a daguerreotype study. Daguerre had announced his version of photography in January 1839, the same month as Talbot rushed out his photogenic drawing account. The daguerreotype process was published in full and keen experimenters soon started making examples. It is possible that Gutch used the newly invented French process at this early date; he almost certainly had the skill to do so. The Revd Calvert Richard Jones (1802-1877) was experimenting with daguerreotypes from 1840 and made a remarkable study of Kit Talbot's majestic Margam Castle in March 1841.

In 1845 Calvert Jones joined his friend Kit Talbot on his yacht in the Mediterranean and later met the Revd George Wilson Bridges (1788-1863) who produced some of the earliest photographs of the Holy Land. The eccentric Bridges later became rector of Beachley, a tiny village near Chepstow, where JWGG made a photograph of him in 1856.

Although Swansea was gaining a reputation as a centre for serious scientific study, Gutch, for reasons unknown, resigned his post of Honorary Secretary at the Institute in the summer of 1840. The committee gave their heart-felt thanks for his exertions and elected him an Honorary Member. He appears to have left South Wales and moved to London soon afterwards. The census of 1841 shows him and Elizabeth living at 36 Great Portland Street with two family servants.

Swansea remained an important centre for landscape photography until the late 1850s and JWGG returned there several times to meet old friends, including Charles Henry Smith and Iltid Thomas, photographs by whom appear, along with JWGG's own studies, in the Gutch family album in the National Trust Collection at Lacock.

3 The Calotype and Wet-Plate Era

The Glorious Sun Stays in His Course and Plays the Alchemyst.

King John, William Shakespeare

In January 1841, only a few months after their move to London from Swansea, Gutch's father-in-law, Robert Jaffray Nicholson, died aged 72 at his home in Devon. In September of the same year his wife Henrietta also succumbed. Gutch's wife, Elizabeth Frances, came from a large Irish family and had at least seven brothers and sisters, all living at Somerset Place in Stoke Damerel, Devonport. It appears that JWGG and his wife travelled to Devon in September that year to attend his mother-in-law's funeral. While staying in Devon, Gutch took the opportunity to make contact with the analytical chemist, geologist, early photographer and writer Robert Hunt (1807-1887), who coincidently was born at Stoke Damerel.

Robert Hunt had published his first paper on analytical chemistry in 1838 and in the following year made successful experiments to produce direct-positive photographic images on paper. In 1841 he published the first practical handbook of photography, just a year after replacing the early photography experimenter Thomas Brown Jordan (1807-1890) as Secretary of the Royal Cornwall Poly-technic Society at Falmouth. It is not known whether Gutch knew Thomas Jordan. They would have had much in common, both were born in Bristol and were interested in meteorology. Jordan had devised a method of making daily photographic records of the sun's progress with an instrument he called a heliograph, barely a month after Talbot's January 1839 announcement of photogenic drawing.

Gutch knew Robert Hunt and seemingly consulted him in early September 1841 about Talbot's calotype process, announced that year. The irrepressible Gutch had already attempted the new method, but Talbot's account of how to produce a negative left a lot to be desired and JWGG appears to have had trouble obtaining a good example. He wrote to Talbot for advice. JWGG's letter, which has probably not survived, was passed via Hunt to Talbot when he was in Falmouth. Talbot had been visiting his uncle, Sir Charles Lemon, at the end of August 1841 and made several negatives in the grounds of his large estate. Lemon was President of the Polytechnic Society and lived at Carclew, not far from Falmouth. Hunt was the society's Secretary and during Talbot's visit an album of his early calotypes was shown at a meeting of society members, either by Lemon, Hunt or Talbot himself, and it may have been then that Gutch's letter was passed to Talbot.

Talbot replied in a letter dated 14 September 1841 to Gutch, who was staying with his wife's family at Somerset Place in Devonport, but by the time the letter arrived JWGG had returned to London and it was re-directed to

his London address at 36 Portland Place.

Talbot's letter to Gutch survives in the Smithsonian Collection, Washington.

Sir,

When I was at Falmouth lately, Mr Hunt put your letter into my hands. Your failure may perhaps arise from some of the following causes: not enough of acetic acid, which should have a pungent odour: using a sponge instead of a brush: using impure iodide of potassium. Mr Hunt assures me that this substance is often sold so far from genuine as to contain two thirds of its weight of carbonate of potash. Many gentlemen have difficulties, but I have not found it possible to ascertain the cause [of failure] by letter. All these difficulties disappear by a little practice.

Mr Hunt informed me that he succeeded upon the first trial, from my printed list.

W.H.F. Talbot

P.S. I also enclose a specimen of good iodised paper, if you like to try it.

Shakespeare's *King John* (act three, scene one) provided Gutch with the 'Glorious Sun Stays in His Course and Plays the Alchemyst' quote that that he used in an essay written for Thomas Sutton's *Photographic Notes* and in at least two of his photographic albums. The cruel King John had strong west-country connections; he had been educated in Bristol and was granted most of south-west

England by Richard I. He was poisoned in 1216 and buried at Worcester Cathedral. These local associations and the quote, so apposite to the chemistry of photography, would have appealed to Gutch, both as historian and scientist.

An early photographer needed to be an alchemist; in the 1840s and '50s operators had to mix their own chemicals, coat their paper or glass negatives by hand and develop them on the spot. Paper for the finished print had to be prepared well in advance in the laboratory. It was a slow, difficult and sometimes hazardous procedure. Fingers were turned black by the silver nitrate. Gutch's fellow Bristol photographer Hugh Owen (1808-1897) is said to have refused to use wet-collodion because he objected to the staining.

Gutch seems to have had no such qualms when he operated his favourite camera, a model that actually incorporated a darkroom built into it. From 1856 onwards he used the combined camera and darkroom designed by Frederick Scott Archer (1813-1857).

Scott Archer was also the inventor, in 1851, of the wet-collodion glass negative process that soon became the method Gutch and most others preferred for producing negatives owing to its improved speed and sharpness over paper. It remained the standard medium for photographers from the mid-1850s until the inception of the dry-plate in the 1870s.

In *Photographic Notes* Gutch describes how the discovery of the recently invented camera transformed his picture-taking prospects:

From ill-health and lameness I was on the point of giving up Photography, when, in the early part of 1856, I was shown for the first time an 'Archer's Camera'.

Prior to Scott Archer's clever solution of combining camera and dark-tent into one it was necessary to have a separate portable darkroom when on location. JWGG suffered with severe gout during his service as a Foreign Service Queen's Messenger (see next chapter) and subsequently had to walk with the aid of a cane. Anything that helped him not having to move between camera and dark-tent was to be welcomed.

The Journal of the Photographic Society in 1854 carried an account from Archer about his new instrument subtitled: 'On a Camera where the whole Process of a Negative Picture is completed within the Box itself':

The aim of the construction of this camera has been to obviate the necessity of a tent or dark room, whilst performing any of the operations necessary for producing photographic pictures. The camera I now submit to your notice folds up when not in use, which renders it portable for travelling, at the same time it is capable of containing all the chemicals, &c. that are required. The camera being mounted on the stand, and pointed to the object to be taken, the focus is obtained on the ground-glass by means of a sliding bar, with the ground-glass in it, it is adjusted to the proper distance, it is fixed by means of a small thumb-screw which runs loosely in the groove on the left side, either before or after the sliding bar against which it is set, and the correct focus obtained. The ground-glass may then be removed, and the prepared surface, either glass or paper, be put in its place; that is ... adjusted to the same plane as the surface of the ground-glass screen, the frames having been carefully adjusted to obtain this end. The camera is then closed behind, and the other operations performed by aid of the yellow light admitted at the top, with the hands passed through the sleeves, the face close to the small opening at the back, and a loose curtain thrown over the head.

In manipulating with collodion on glass, it is used as follows. The focus being obtained as previously stated, the collodion is poured on the glass plate just inside the camera. When sufficiently dry, the plate is placed in the silver bath, in the bag at the end of the camera, and allowed to remain there from two to three minutes. The camera is then closed; the prepared glass is removed from the bath, and placed in the frame previously adjusted for it, by passing the hands through the sleeves. After due exposure to light, it is removed from the frame, and held in the left hand horizontally, whilst the developing solution is poured on and allowed to flow evenly over the surface. The development of the image is now watched by means of the yellow light at the top of the camera. When the image is sufficiently brought out, the plate is plunged

into a bath of salt and water, which prevents any further development of the image. The camera can now be opened, and the picture be removed into the open air, and finally fixed with hyposulph.soda, or preserved in the state taken from the camera, for any length of time.

All of the whole-plate photographs made by Gutch from early 1856 onwards would have been made in this manner. Prior to the wet-plate process, which Gutch took up using half-plate negatives and a smaller camera from before 1854, he used paper-negatives. He employed an Andrew Ross & Company 'view-lens' for most of his landscape work and later, when tackling the churches in Gloucestershire, a Ross Petzval lens, which was 'faster' and had better coverage. Not everybody was impressed by Archer's camera; the Jersey-based photographer and feisty editor of *Photographic Notes*, Thomas Sutton (1819-1875) declared that:

> Photography has difficulties enough without inventing fresh ones, and trying to manipulate under excruciating circumstances of discomfort.

A *Photographic Notes* correspondent found the camera: 'an ugly and clumsy piece of apparatus, about 26 x 15 inches.'

Gutch found the 'clumsy' camera to his liking however and soon mastered the tricky technique required. He prepared his plates using chemicals supplied by his friend the Clifton druggist (pharmacist) and fellow amateur

Thomas Cadby Ponting (1819-1868). JWGG was so impressed with the quality of the collodion supplied by Ponting that he asked him to prepare it in November for use the following summer, claiming that the solution improved with age.

After coating the plate and exposing it for the required time Gutch would have watched through the camera's yellow-glass window to see how his favourite developer, consisting of pyrogallic, citric and aectic acids dissolved in alcohol and water, was acting on his latest negative. Once the plate was developed, fixed in 'hypo', the widely used name for sodium thiosulphate, washed and dried, JWGG was still not quite finished. As protection he still had to varnish the glass-plate, for which he used 'Gaudin's Varnish', formulated by the French photographer, optician and scientist Marc Gaudin (1804-1880) who, in 1853, proposed using the highly-poisonous potassium cyanide as a fixing agent.

Gutch, unlike many other amateurs of the period, stuck to his preferred technique of producing negatives; in *Photographic Notes* he tells us that:

> Indeed I would set it down as a photographic axiom to let well alone, and when real success is arrived at by any of the thousand processes advocated, to abide by that, and on no account be seduced by restless friends to try theirs, and thereby waste much valuable time, and lose much equanimity of temper, and probably produce negatives most unsatisfactory.

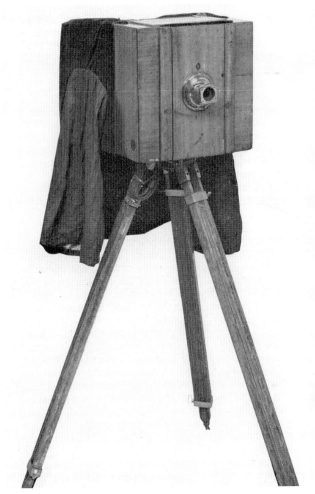

A Scott Archer camera of the type used by Gutch

spot the bulky camera had to be unpacked, the tripod assembled, the picture composed and the inverted image on the ground-glass focused under a dark-cloth. The glass-plate was prepared inside the camera, inserted into its holder and exposed while still damp. Shutters had yet to be invented and the usual method of exposure was to un-cap the lens. Wet-plate exposure times varied considerably but were relatively fast when compared to the earlier paper negative process, when fifteen minutes or even far longer was not uncommon. A typical wet-plate exposure time for a landscape in reasonable light was probably anywhere between two and twenty seconds. The only known reference to the exposure time of a photograph by JWGG was eight seconds (a view of Bristol Bridge in 1858).

Once Gutch returned home from his photographic excursions, which often lasted for two or three months, he had to make his prints. Only good-quality writing paper made from cotton rags and free from spots was chosen for this task. Well-sized paper was generally preferred as it had better wet-strength. English paper tended to be sized with animal gelatine and French paper with starch. The home-grown papers gave a warmer tone. The English papers used by Gutch varied in weight considerably; some later prints are watermarked 'Towgood 1858'.

From 1839 until the early 1850s the salted paper print was the main medium for the finished photographic print. In the mid-1850s many photographers started using albumen (egg-white) to coat their papers. The addition of

30

Taking photographs in the field was a slow process in the mid-1850s; Gutch travelled to his locations by steam train, canal barge and horse and carriage. Once at the required

albumen (in varying dilutions) was generally thought to improve the quality of the picture, partly by protecting the image from fading and giving a sharper image. Generally Gutch remained true to the traditional salt print, even though many other photographers had ceased using what by then was considered to be a dated method. It suited his traditional vision, despite using the glass negative process which gave a much sharper image. He did not want his finished print to look too glossy or commercial. Many of Gutch's prints might be described as 'lightly albumenised' but more typically they have the usual salt print flat-matt appearance. Many of his salt prints have faded in the 150 years since they were made, but those that appear to have been toned during processing have survived well.

The general method of preparing a home-made salt print involved soaking high-quality paper in a weak solution of common salt (sodium chloride). After being dried, one side was brushed over with a silver nitrate solution (90 grains to a fluid ounce of distilled water was a general guide). This procedure was performed in the dark room aided by the weak light from yellow-glass or a candle. Once it was dry Gutch often marked one corner of the paper with pencil to show which side was sensitised.

When exposed in a printing-frame to sunlight the image formed itself without the need of a developing agent, although some operators did 'develop-out' their prints. The time required to produce a visible fully-formed image depended on the strength of the daylight and density of the negative, but anything from three to sixty minutes was considered the norm. Gutch would have inspected the print as it progressed, removing it from the frame when considered dark enough.

The print then had to be 'fixed' and preferably toned; from 1855 onwards Thomas Sutton was a staunch advocate of the French method of toning the print with gold chloride. The toning process not only improved the colour of the image, but also improved its stability.

The permanence of the photographic image was a major concern to both the makers and buyers of photographs. Many early images 'faded away' on exposure to light and through chemical degradation. Gold toning was preferable to the popular method of using 'the old-hypo bath' which had various chemical additions that improved the print's colour, but often contributed to the degradation of the silver image, particularly if not properly washed.

Gutch claimed in *Photographic Notes* to have produced some 2,800 prints in 1857 with 'the assistance of only one other person'; this would have been a very time-consuming and costly process, with little time for strict print control. He probably reserved the toning process for his favourite pictures. Writers at the time suggested leaving prints in the toning bath for up to twelve hours and then re-fixing for half an hour, followed by washing in running water for 'several hours'.

4 From Queen's Messenger to Malvern

'In Search of Health and Happiness'

Although he trained in Bristol as a surgeon and practised as a physician in Florence and Swansea, Gutch appears to have given up medicine by 1842 or 1843, less than three years after moving from South Wales to London. It is unclear why he retired from medicine; he may have been, like many other practitioners of the time, frustrated by the limited choice of treatments that he could offer to his patients.

Around this time he started a twenty-year stint editing the annual *Literary and Scientific Register* and on 18 October 1843 was appointed a Foreign Service Queen's Messenger, a post he was to hold for more than ten years. His well-educated literary background and social contacts would now determine his future professional career as both an editor and 'Silver Greyhound', as a Foreign Service Messenger was then known. The income both from his government post and as editor of the annual scientific register allowed him to pursue the scientific interests cultivated in Swansea.

The statesman George Canning (1770-1827) is credited with introducing the corps of King's Foreign Service Messengers when he was Foreign Secretary in 1822. The origins of the service stretched back to the late-fifteenth-century 'Knights Caligate of Armes' (College of Arms). These early messengers became known as 'knight riders',

who, following several years' service, eventually rose through the ranks to become *pursuivants*, and finally heralds. Following his retirement from the service JWGG appealed through the pages of *Notes and Queries* for information on the history of these romantic figures.

Canning's nineteenth-century messengers tended to be picked from the army officer class to undertake the task of safely delivering important documents to British embassies and foreign heads of state. The men chosen for the task had to be British subjects of sound health, good manners and an ability to speak French, German or Italian. Although never an army officer, Gutch was confident in languages, following his time on the continent, but he was seldom 'of sound health'.

Being a Queen's Messenger meant that Gutch enjoyed a first-class carriage when travelling by railway and a private cabin when at sea. A formal uniform was worn when receiving or delivering dispatches, along with a badge in the form of a silver greyhound. The most sensitive letters were carried close to the body in a leather wallet, lesser documents in dispatch-boxes.

He took a camera with him on at least one of his overseas trips and in May 1851 made a whole-plate paper negative of the Spanish Minister of War's Residence in Madrid (National Trust Collection, Lacock).

It would perhaps have been considered risky for a messenger to be seen making photographs in foreign countries and he could have easily been taken for a spy. He appears to have made foreign views only very rarely and at the time of writing no other such views have been definitely attributed to Gutch. He travelled widely during his decade as a Queen's Messenger and is known to have visited France, Spain, Austria, Norway, Russia, Greece and Turkey. In March 1850 Gutch the messenger was at Salamis Bay in Greece, having delivered a dispatch from Viscount Palmerston to diplomat Sir Thomas Wyse during the 'Pacifico Affair'.

The Queen's Messenger was often not fit enough to undertake his duties and in March 1848 his doctor considered him too unwell to travel. Three years later Gutch describes himself as 'incapacitated from service by gout'. This slightly curtailed his income; in 1851 he received £528 rather than the £700 he would have expected for a full year. This was a good income at the time, although the figure may have included his expenses. He retired with a Foreign Service pension on 9 July 1854.

Following his retirement JWGG made many photographs of friends and family using half-plate wet-collodion negatives; he also collected the occasional portrait from friends. The Gutch family album (National Trust Collection) contains a number of studies showing the children of the High-Victorian interior decorator John Gregory Crace (1809-1889). These portraits are the work of Crace himself rather than Gutch and it seems that the two men were close friends who exchanged family photographs. Crace was a keen amateur who made the portrait of JWGG in the J. Paul Getty Museum collection and was an early member of the London Photographic Society who exhibited a few photographs 1854-56. Following a breakdown Crace travelled to southern Spain in March 1855 and made photographs of the Alhambra. It seems that he saw this as a kind of therapy. A year later, perhaps encouraged by Crace, Gutch prepared to make his way to Malvern 'In Search of Health and Happiness'.

The spring of 1856 marked a turning-point in Gutch's output; prior to this he had been involved in much photographic experimentation from the earliest days. He may have made daguerreotypes and photogenic drawings. He certainly made calotype negatives including some whole-plate landscapes and later, smaller portraits using glass negatives. With the move to a Scott Archer wet-plate camera he now concentrated on making architectural and landscape studies of specific locations, often spending many weeks in one place.

In early April 1856, just days prior to his pilgrimage to Malvern, Gutch took his bulky camera to the Cheddar Gorge in Somerset, about ten miles south of Bristol. This may have been a test-run for his new camera. He made a study of the rocky limestone cliffs from high above the gorge, a viewpoint that must have involved a strenuous climb. Gutch now realised that if he could manage, despite his infirmity, to cart his cumbersome camera, tripod, heavy glass plates and chemicals to the top of a steep ravine, then

he could manage it anywhere. The gentle Malvern Hills should present no obstacles.

The spa at Malvern was an obvious choice for Gutch, who was looking for treatment for a kidney complaint and his severe gout. It was close to his father's home near Worcester and had recently grown into a well-known centre for hydrotherapeutic treatment for the upper classes. Darwin, Dickens, Carlyle, Tennyson and a host of other luminaries had visited the baths there in a bid to cure a variety of Victorian maladies. Gutch himself had harboured an interest in water-treatments since his time in Italy, when he made drawings of the baths in the spa town of Lucca.

Malvern had been developed during the 1840s as a centre for water cures by disillusioned doctors James Wilson and James Manby Gully. Fellow surgeon Gutch took his treatments under Dr Gully (1808-1883) who lived at The Priory. The 'cures' offered included cold-water douches and 'wet-sheeting'. Occasionally warmth was introduced when heaters were placed near the patient and the victim slowly 'steamed'. Early nights and plain food washed down with countless glasses of mineral water completed the experience. Two years after Gutch's visit the *Bristol Times and Mirror* journalist Joseph Leech wrote an amusing account of the rigours at Malvern entitled: 'Three Weeks in Wet Sheets: Being the Diary and Doings of a Moist Visitor to Malvern.'

Gutch survived the wet sheets and seemed to benefit from the invigorating regime at Malvern. Five years earlier

Charles Darwin's sickly young daughter Annie was taken to Dr Gully for treatment; she found no relief from her condition and was soon dead. She was buried at nearby Malvern Priory. Gutch was obviously concerned with his own mortality when he made three studies in the abbey churchyard during his sojourn at Malvern. One photograph shows Gutch leaning on a gravestone; it has these anonymous lines penned beneath:

There is a world of death beneath our feet.
There is a world of life above our heads.
Here ruins, graves, dried leaves, fall'n blossoms meet.
There, God in light & air his glory spreads

Another churchyard study is similarly annotated, this time by romantic poet Walter Savage Landor (1775-1864) who, in common with Gutch, had at one time or another lived in Florence, Swansea and Bristol.

Oh parent earth! In thy retreats
My heart, with holier fervour beats.
And fearlessly, thou knowest well
Contemplates the sepulchral cell

Coinciding with Gutch's two-month stay at Malvern local publisher H.W. Lamb produced a volume by Edwin Lees entitled: *Pictures of Nature in the Silurian Region Around the Malvern Hills and Vale of Severn: Including Excursions with*

the Worcestershire Naturalists' Club and Notices of the Natural History, Pictorial Scenery, Botany, Geology, Customs & Superstitions.

This was the very book that Gutch could only dream of; it was the perfect volume; incorporating in its wonderfully long-winded title everything that interested him. Edwin Lees (1800-1887) was an author and botanist and JWGG used his comprehensive writings as inspiration for many of the studies he made in and around Malvern.

Gutch produced at least two albums containing photographs of his time in Malvern and they almost certainly constitute his earliest comprehensive record of a particular location. Great Malvern Part I concentrates on his time in the spa town of Malvern itself. Great Malvern Part II is more topographically varied; an ancient oak and elm associated with local folklore, dark landscapes and abandoned buildings all form a more personal response to the Worcestershire countryside.

5 Lynmouth, North Devon

This little area is a fine school, wherein the mind may learn nobility; cast off with shame every littleness or fancy ... & from humility learn to be great.
The Sketcher Revd John Eagles

Lynmouth in North Devon had proved to be a magnet for artists and poets well before Gutch arrived there at the end of July 1856. He was refreshed after his sojourn at Malvern and eager to enjoy the picturesque pleasures of this fishing village. He arrived there by coach from Bridgwater, following a train journey from Wells after photographing the cathedral there.

The poet Southey stated that it was 'The finest spot, except Cintra and Arrabida that I ever saw.' He goes on to describe the lie of the land:

Two streams join at Lynmouth ... each of these flows through a coombe, rolling down over huge stones like a waterfall; immediately at their junction they enter the sea, and the rivers and the sea make but one noise of the uproar. Of these coombes, the one is richly wooded, the other runs between two high, bare, stony hills.

'Lynmouth ... the most delightful place for a landscape painter this country can boast', declared the artist Gainsborough in a letter to the artist and proponent of The Picturesque, Uvedale Price (1747-1829). Gutch's earliest-known picture at Lynmouth shows the harbour with its distinctive tower, along with a few blurred dinghies bobbing on the sea. A few days later he moved down to the beach at low tide and made a panorama of the sea-wall and old cottages. A second panorama shows the pier and foreshore; a small child reclines on the pebbles to give a sense of scale, but there is no sign of the local fishermen in Gutch's Lynmouth photographs. He was seeking the picturesque landscapes and riverscapes which had attracted the painters and poets.

Gutch concentrates on the East Lyn, considered to be the more accessible of the two rivers. Horse-drawn carriages, ponies and donkeys were available to transport tourists, artists and photographers, complete with their easels or tripods, along the river banks and steep valley paths. In one study amateur artists are pictured by Gutch sitting beneath an overhanging cliff-face near the beach with their sketch books, no doubt bringing to mind lines from his father's friend Revd John Eagles' poetry volume, *The Sketcher.*

The artist George Price Boyce (1826-1897) visited Lynmouth in 1858 and made a watercolour near Middleham, a hamlet beside the river that was destroyed by the disastrous flood that took away most of Lynmouth, along with thirty-four residents, in August 1952. Gutch made many studies on this stretch of the East Lyn, his long

exposures turning the rushing torrent into a milky swirl. Artists like Boyce 'froze' the water, painting it with the same precision as they depicted the giant boulders that the stream ebbed around.

In 1857, a year after Gutch's visit, William Henry Millais (1828-1899) made a large panoramic watercolour measuring almost seven feet in length, but not much more than a foot in height, showing the Valley of Rocks near to Lynton, the village immediately above Lynmouth. Gutch made at least two photographic panoramas in North Devon, not an easy task, but he seems to have been particularly skilled at it. Perhaps Millais' giant panorama was inspired by photography's ability to render, through multiple overlapping negatives, a broad sweep of the landscape. Potentially a 360-degree view was achievable but most practitioners stuck to two, three or four plate views, taking in a view encompassing between 90 and 180 degrees.

Gutch also photographed in the Valley of Rocks and made at least one study of the dramatic Castle Rock. He appears to have left Lynton and Lynmouth after spending all of August 1856 there and made his way to the south coast where he photographed the recently-built broad-gauge railway that ran along the beach at Dawlish. He made several studies on the sands there, including a multiple-plate panorama now in the Wilson Centre of Photography Collection.

6 The Lake District

But who can paint Like Nature?
Can imagination boast amid its gay creation hues like hers?
Thomson's *Seasons*

Gutch arrived in the English Lake District in early July 1857 following a two-month photographic tour recording some of Scotland's most romantic ruins, concentrating on the cathedrals and abbeys that had poetic associations, many of them immortalised through the works of Sir Walter Scott. Scott had been dead and buried for a quarter of a century but his writings still influenced the mid-Victorian imagination. Visitors flocked to the abbeys of Melrose and Dryburgh as well as Scott's former home at Abbotsford to pay their respects. There is evidence that many of Gutch's Scottish studies were taken as part of a commission for the recently formed Architectural Photographic Association; he exhibited at least five prints at their two exhibitions in 1858. Many of the images made during April and May survive in an album in the George Eastman House collection and consist almost exclusively of architectural studies.

Before he started his Lake District tour Gutch spent a week at the Manchester Art Treasures exhibition that opened in the city's Trafford Park in May 1857. The catalogue of 539 photographs does not list JWGG as an exhibitor, but it is possible that he showed a small selection of his work. More than 80 professional and amateur photographers were included in the large display, and Gutch would have been able to view impressive entries from a host of Italian and French masters including Alinari, Bisson and Le Gray. Closer to home there was work by several early English professional architectural and landscape specialists, including Francis Bedford, Roger Fenton, Robert Howlett and George Washington Wilson. All of them displayed prime examples of their work.

The majority of photographers represented at the exhibition were considered to be 'gentleman amateurs', several of whom worked in a similar style to JWGG, although often in a larger format. Exhibitors at Manchester included members of Gutch's Bristol and Swansea circle including Philip Henry Delamotte, Thomas Cadby Ponting, James Knight and J.D. Llewelyn.

The first president of The Photographic Society, Dr Hugh Diamond (1809-1886), showed a dozen portrait studies from his series depicting 'insane women' and the eccentric Oscar Gustav Rejlander (1813-1875) displayed his large and complicated allegorical tableaux 'Two Ways of Life'. This artistic view of semi-nude women in a quasi-religious setting caused a sensation and was barred from several other exhibitions. Copies of the full-sized version

were available at ten guineas. Gutch operated on an altogether smaller scale than the flamboyant Rejlander and would have perhaps frowned on his somewhat vulgar composition.

Of those exhibiting at Manchester the closest in style to Gutch was the prolific amateur Henry White (1819-1903), who also used wet-collodion to produce his negatives. He showed 33 small studies of rustic scenes taken near his home in Surrey. Wealthy Worcestershire amateur Benjamin Brecknell Turner (1815-1894) worked on a more impressive scale and produced 12-by-16-inch salt or albumen prints from his waxed-paper negatives. His chosen subject matter was much like Gutch's; rustic architecture and tree studies predominate, but his pictures were much bolder, their texture and size making them stand out. Turner's large prints were priced at around seven shillings and sixpence; JWGG's more modest efforts were only a third of this price.

Gutch was an avid collector; we know he collected plants, insects, books and engravings as well as facts and figures about an extraordinary range of subjects. His own photography was, for him, a kind of collecting and few, if any, other photographers of the period would spend two or three months in one location making a coherent study of a particular place. Of course, photography is an infinite art; no one could ever 'collect' every scene encountered, therefore he generally limited himself to places that had literary and artistic significance and in a way the subject matter was often dictated by association.

The Lake District had become the home of English romantic poetry in the first quarter of the nineteenth century. Several of the Lake Poets including Wordsworth, Coleridge, Southey and De Quincey were known to Gutch's father, and JWGG himself may have met some of them as a young man at his father's house in Bristol. All except De Quincey had died prior to Gutch's visit in 1857 but Gutch managed to pay a kind of homage to the others by recording their homes and graves during his visit in the summer of 1857. No doubt he later provided copies of his photographs to his father as a memorial of his late friends.

Often Gutch did not find it easy to make the pictures he wanted during his time in the Lake District. English landscapes are hard to portray photographically; the scenery is generally undramatic; the light and weather often poor. At the time it was difficult to achieve drama in the blank skies with some well-placed clouds unless tricky combination-printing techniques were applied later. Gutch would have left such 'trickery' to the French master Le Gray.

In Gutch's *Recollections and Jottings of a Photographic Tour, Undertaken during the Years 1856-7* he laments photography's limitations and gives some idea of the number of artists attracted to the area:

Judging from the multitude of artists that one meets wherever one wanders in the Lake District [I] should think that more umbrellas, palettes, portable easels, and all the usual artists' paraphernalia, are consumed

there, [than] in any other part of our Island; but notwithstanding all this evident attraction, I am not quite sure that it is pre-eminently the country for the Photographer. [That] the Tourist meets with many a striking and eligible bit of scenery in each day's perambulation, and well calculated for the photographer, I will not deny, but I think 'tis better fitted for the brush and the painter; the distances are too great, the pictures too large, and the aerial perspective, which gives such a charm to the Lake scenery, unattainable in photography, at least to the extent which will do justice to the unrivalled scenes that have met one's eye.

Despite his reservations, Gutch, perhaps inspired by seeing the 500 photographs at the Art Treasures Exhibition two months earlier, was full of enthusiasm and recorded a wide variety of his favourite subjects in Cumberland and Westmoreland, compiling at least two albums from his stay there. He had sufficient time and the inclination to make a few four-part panoramas there including Bowness Lake from the Victoria Hotel. He made a news picture at Windermere when he photographed the *Lady of the Lake*, a well-known steamer that had recently been burnt out. The huge and romantic Wray Castle, built some years earlier by Liverpool surgeon Dr James Dawson, was found worthy of three negatives, as was Backbarrow Mill at Newby Bridge. Three days were spent at Furness Abbey, where he made at least eight good negatives. But it was not only ancient ruins that came under his lens;

Wordsworth's and Hartley Coleridge's tombs at Grasmere were sensitively recorded and three views at Coniston completed his first month's photography.

By August Gutch was making studies in and around Keswick, where he made a good panorama of the town. Greta Bridge and Southey's former home at Greta Hall were well documented and JWGG even copied a pair of gloomy paintings of the late poet's bedroom and dining room. The Oxford-educated Southey (1774-1843) had been appointed poet laureate in 1813 and was a member of Coleridge's and Wordsworth's circle (that at one time included Gutch's father). His nephew Reginald Southey (1835-1899), himself a competent photographer, is credited with encouraging Lewis Carroll (Charles Dodgson) to take up photography at Oxford around 1853. It is not known whether Gutch knew Lewis Carroll; although he may have known Reginald Southey through his uncle, the poet.

Lewis Carroll (1832-1898) had visited the Lake District in 1857. He photographed Tennyson at Ambleside and family and friends at Crosthwaite in late September, just a couple of weeks after Gutch had left the area. In June that year the young Oxford don had made studies of human and animal skeletons, including a strong study of the bleached bones of a giant ant eater in the Anatomical Museum at Christ Church in Oxford. Gutch's study of a similarly bleached skeleton, of a horse, that appears incongruously on the wall of toll-keeper John Dodd's house at Castle Hill near Bassenthwaite is perhaps the most extraordinary of all his known photographs. Gutch would have made his

photograph, *Brackenrigg Toll Bar, Bassenthwaite*, when he travelled through the turnpike during a photographic excursion from Keswick, probably on one of the many coach trips suggested in the tourist guide books.

Rather than passing by this unique scene Gutch stopped, set up his camera, coated his plate and persuaded the toll-keeper to pose. The well-dressed central figure of 40-year-old John Dodd rests his elbow casually on the fence, just by the gate, in a pose reminiscent of a character in a Western film. The gate is open, allowing us to see wooden farm implements propped up against a white wall just beyond.

Many other early photographers would have perhaps made a study of the rustic implements themselves. Gutch, as usual, wanted to show the scene as a whole. A wooden fence (a recurring subject in Gutch's vision) runs across the scene and takes the eye to the toll board which gives the conditions and prices charged to use the turnpike. Strangely, the skeleton of a horse stands in a large, black, shallow box above the toll-keeper's door.

How and why the horse came to be preserved will surely remain an enigma; was it a famous mount that travelled the nearby roads in previous years? Had it perished nearby one winter? Or, was it purely put up as a warning, a grim reminder to pay your toll? Had it been on display for some time, or was it a recent addition? Of course it may have been put up purely as an attraction. Go up to Brackenridge Bar and see the skeleton! How long it remained there can only be guessed at. In that August 1857 Gutch made a negative knowing that he would be unlikely to pass that way again. He had made another picture to add to his growing collection.

The standing stones of the Druid's Temple near Keswick made an impressive four-part panorama (one part missing and the surviving prints damaged). In another picture the dramatic cliffs of St John's Vale loom over a new wooden fence that leads up to a substantial stone barn. It is only when Gutch photographs the waterfalls at Borrowdale and Lodore that we see a landscape untouched by man. Even his *Old Oak, Monk's Hall Farm near Keswick*, has a small wooden sheep-fold and a pair of cart wheels abandoned next to it.

Gutch's final Keswick pictures, taken in late August and early September, show how the Industrial Revolution had brought change and increasing prosperity to rural Britain. The slate quarry at Borrowdale displays its blasted face; the extensive pencil factory at Keswick is seen prominently from Southey's Greta Hall and a large water-powered tannery all show how the area was changing from its former rural idyll.

Gutch copied the following verse taken from *The Sketcher* by Gutch's father's old friend Rev John Eagles into his Lake District Part II album:

Oh ye are fools that love to stand
above your fellow men;
To scatter by the wave of hand,
and kill by stroke of pen.

The sunshine & the greenwood shade
For peace & innocence were made.

Despite photographing in the Lake District well into September, Gutch had still not finished his 1857 photographic odyssey. He now travelled to the recently-developed coastal resort of Llandudno in North Wales where he produced a large number of negatives documenting the town. He spent at least two months in Llandudno, Conway, Bangor and Beaumaris and made many good studies, including coastal views, churches, castles at Conway and Beaumaris, aristocratic family seats, slate quarries, bridges and even a windmill. He carried on making pictures until as late as November, in what was probably his most productive year.

7 Penzance and West Cornwall

Is there not Cornwall if we would be remote
and solitary?

The landscape and people of western Cornwall provided Gutch with some of his best visual material. By 1858 he had become a very practised photographer with at least seventeen years behind him and he was seemingly fit enough to manage the steep cliffs and bleak terrain of the area around Penzance.

Gutch arrived in a 'bright and brilliant' late July and took his final pictures in the 'heavy and dull' light of early October; during this three-month period he managed to make over one hundred photographs, including coastal landscapes, rock formations and portraits. JWGG described his arrival in *Recollections and Jottings of a Photographic Tour during the Year 1858. Photographic Notes*, vol.4:

> It requires a fortnight to 'settle down' comfortably in a new locality, and discover 'how the land lies'. At first, one flits about like a bee over a garden of sweet flowers, culling honey from the sweetest only; so the photographer naturally visits the usual 'lions' of the place; tho' after a few weeks residence he begins to find out for himself many a point of interest not inserted in the Guide Book of the place.

The west of Cornwall would have appealed greatly to Gutch; its geology, ancient rock tombs, history and botany (particularly lichens, heathers and grasses) were all to his taste. There were few, if any, of his favourite trees to photograph, but he had other subject matter; in fact he was overwhelmed with choice.

> Here, and at Land's End, is plenty of work for the camera; dozens and dozens of good pictures may be taken; the subjects are endless. The name of this picturesque little nook is Porthcurno, and from it the Logan pile of stones stands out in full majesty.

Despite having a seemingly endless choice of subject matter Gutch was of course limited by his equipment and the slow process of wet-plate photography. In Scotland the year previously he mentions making eight negatives over two 'delightful' days at Melrose Abbey. Exposures by the bright Cornish coast would have been shorter than those at the dark ruins of Melrose, but even on a good day he still probably produced fewer than half a dozen plates. In Cornwall cliffs and rock formations replaced the crumbling abbey ruins that provided Gutch's usual fare.

The group of rocks here is wonderfully fine... the weathered granite rent and riven in every direction by the action of the air and the stones of ages.

Gutch, however, did not limit himself to merely recording natural rock-formations: he also made many studies of the man-made Neolithic rock tombs variously known as quoits, cairns or cromlechs. Gutch was fascinated by geology, and rock formations certainly made good subject matter, their very nature conforming to the prevailing taste for The Picturesque. As Richard Meara says in his introduction, the Revd William Gilpin (1724-1804) had promoted the idea of The Picturesque at the end of the eighteenth century; more than fifty years later it was still influencing artists and photographers. Gilpin gave this rocky view in 1792:

> The rock, as all other objects, though more than all, receives its chief beauty from contrast. Some objects are beautiful in themselves. The eye is pleased with the tuftings of a tree: it is amused with pursuing the eddying stream; or it rests with delight on the shattered arches of a Gothic ruin ... But the rock, bleak, naked, and unadorned, seems scarcely to deserve a place among them. Tint it with mosses, and lichens of various hues, and you give it a degree of beauty. Adorn it with shrubs, and hanging herbage, and you make it in the highest degree interesting. Its colour, and its form are so accommodating, that it generally blends into one

of the most beautiful appendages of landscape.

Gutch exhibited *Illustrations of Geological Stratification* in a frame 'containing four views' at the February 1858 London Photographic Society exhibition. A critic reviewing Gutch's exhibited studies commented in the *Athenaeum*:

> Here we have the very split and cleavage of stone, its crumbles, hollows, frets, angles, mammocks, ledges and multitude.

A series of almost fifty 'Geological Phenomena' photographs by Gutch were available through the booksellers Messrs. Rowe and Weston. It is unclear where these and the rock studies exhibited in 1858 were taken. Some were probably made in the Lake District or Devon and from earlier (unrecorded) visits to Cornwall.

Of the more than one hundred glass negatives Gutch made in Cornwall between July and October 1858, his studies of fishermen with their families and groups of young miners are perhaps some of his finest. On previous excursions he had often bemoaned the children that crowded around when he took out his camera. In *Recollections* he praises the Cornish locals:

> The girls and boys in these parts are well-behaved, and fine specimens of clean well-dressed, and handsome children. I never ceased in all my rides to admire the children around Penzance; not ragged, dirty, ill-fed

urchins, but well-dressed, well-washed and respectful. The parents I believe, when in work, get well paid, and with punctuality. From several of the small towns in this part of Cornwall several have left for California and Australia; and here and there I heard of them returning with, to them, untold gold, purchasing some large farm, and astonishing their fellow-villagers at their vast acquisition of wealth. One man had come home with £1,500. He left his country as a poor man, earning his weekly wage of 30s a week, and now returns a wealthy landowner.

Despite their solemn expressions, his portraits of young miners show a certain dignity. They dutifully posed and kept still for Gutch's lens, despite never having been photographed before.

A printed list, published by Penzance bookseller E. Rowe in 1859, records the 100 photographs made by Gutch from his Cornish series of 1858, along with a selection of nearly 50 geological studies, many made earlier. The buyer could purchase single views at two shillings, or 'In a Drawing Book, containing 11, and a Floral Title' for a guinea. The same studies were available at Mr Weston's bookshop in Corn Street, Bristol. It is not apparent how many single views or album compilations were sold, a few mounted studies have appeared at auction, only one small Cornish album containing just 11 views (now broken up) is known. In both the 1859 and 1860 London Photographic Society exhibitions JWGG offered examples of his

A published list of Gutch's Cornish photographs

Cornish cromlech studies, mounted on card, also at two shillings each.

Five of Gutch's negatives are preserved in the collection of the Royal Institution of Cornwall, each depicting a cromlech. They were donated by a William Dotesio in July 1940, during the Second World War. At the end of the nineteenth century a firm of printers and publishers operated from Bradford-on-Avon near Bath with the same surname. The negatives, after JWGG's death, had perhaps passed to the Wiltshire business and it seems that a descendant managed to save at least these few. They are the only glass

negatives by Gutch that are known to have survived.

When in Cornwall Gutch often visited and stayed with members of the gentry and clergy, many of whom were friends and acquaintances; he photographed several of their country houses including Trereiffe, Kenegie, Pendrea, Trewidden, Acton Castle (J. Lanyon) and Alverton Cottage (A. Bennett). Trereife [JWGG's spelling] was home to Revd Charles Valentine Le Grice (1773-1858), an old schoolfellow of JMG, Coleridge and Lamb. Gutch visited Le Grice and paid his father's respects just a month or two before the elderly vicar died. Kenegie was the home of eminent London surgeon William Coulson (1802-1877). Coulson trained in London and Berlin and was senior surgeon at St Mary's Paddington. JWGG was undoubtedly a friend of his fellow surgeon and writer. Wealthy locals Richard Foster Bolitho lived at Pendrea and Edward Bolitho (1804-1890) at Trewidden, famed for its gardens then and now. In return for their hospitality and help in providing occasional transport courtesy of their coachmen, Gutch made pictures of all their properties and no doubt provided them with prints of other local scenes.

Gutch was never again to make better images than those he took in Cornwall; his musings in *Recollections and Jottings* sum up his mood after the summer's work.

There is nothing more delightful than after a summer's session of active work, (always conversing photographically, of course), well spent, healthfully, instructing, and profitably, to sit in an easy chair before one's own fire, in the following winter, (the colder the better if you so like it), with the 'loud hissing urn,' and to muse over what has been accomplished. Tis a pleasant dream; the friends made, the difficulties encountered, the mishaps, &c., all fill up a picture (to my mind unequalled); and full of subjects for deep thought and meditation.

8 The Final Years

Piled steep and massy, close and high,
Mine own romantic town.

What is a church? – our honest Sexton tells
Tis a tall building, with a spire and bells.

Although Gutch maintained a house in London's Great Portland Street in the 1850s and later at Upper Charlotte Street in Fitzroy Square, he often spent months away on photographic trips. He had a regular income from both his pension as a former Queen's Messenger and as paid editor of *The Literary and Scientific Register*. The editorship of this annual volume would have allowed him plenty of free time for travel and photography in the summer of each year. He maintained many contacts in Bristol and the West Country and would often have made the journey between London's Paddington and Bristol's Temple Meads stations.

Bristol was home to several other gifted early photographers, the finest of whom was Hugh Owen (1808-1897). Owen was the chief cashier of Brunel's Great Western Railway and well known to Gutch. He had started his photographic experiments using the daguerreotype process in the early 1840s. By the end of the decade he had become skilled at producing paper negatives and was commissioned to produce a series of photographs of the 1851 Great Exhibition. Other early local amateur photographers included Revd Francis Lockey, John H. Morgan, Thomas Cadby Ponting, Charles Brittan, John Bevan Hazard and William West. Early Swansea photographers Calvert Richard Jones and John Dillwyn Llewelyn also made photographs at Bristol; Jones made many negatives of ships in the harbour there and Llewelyn made studies at the zoological gardens in 1854.

Bristol landscape artist and pioneer photographic experimenter William West (1801-1861) was one of the first people ever to exhibit photogenic drawings. In April 1839 visitors to his observatory and *camera obscura*, built ten years earlier within a ruined windmill on the downs above the Avon Gorge, could view examples made by Talbot's recent process and purchase 'photogenic paper' to conduct their own experiments. Twenty-one-year-old Gutch would have no doubt visited West's *camera obscura* (which still exists) when it was first constructed in 1829; the attraction was within easy distance of his family home in Redland.

Almost 30 years later, in April 1858, during one of his return trips to his native city, Gutch photographed the large Gothic church of St. Mary Redcliffe which had been the romantic inspiration for the tragic young Bristol poet Thomas Chatterton (1752-1770). A dramatic reconstruction of Chatterton's death by poisoning based on the noted painting by Henry Wallis, was published as a stereo card by the photographer Joseph Elliott some 80 years

A popular stereocard photographed by Joseph Elliott c.1860, showing a reconstruction of the death of the young Bristol poet Thomas Chatterton

after the poet's death.'I thought of Chatterton, the marvellous Boy, The sleepless Soul, that perished in his pride'.

Amongst other pictures, Gutch made a three-part panorama (in a vertical format) of St Mary Redcliffe, which was then undergoing restoration. This was the grandest of all the churches in Bristol, attracting artists and fellow photographers including Owen (who was married there), Hazard and Lockey. The Revd Francis Lockey (1796-1869) continued working with large paper negatives until the end of the 1850s and in 1858, the same year as Gutch, made at least three studies of St Mary's during its restoration. Lockey was the vicar of Swainswick near Bath and made a comprehensive record of ancient buildings in Wiltshire, Somerset and South Wales between

1853 and the end of the decade. His exposures on paper were extremely long; ten minutes or more was not unusual. There are no figures appear in his photographs, although occasionally the faint 'ghost' of a person or carriage will appear.

Gutch's exposures on glass were much shorter at just a few seconds; this allowed him to complete many more photographs. His project to record every church in Gloucestershire would have been impossible without the faster collodion process. Gutch made many other studies in and around Bristol between April and June 1858, before taking his camera to the wilds of Cornwall. Recently completed Bristol buildings such as the General Hospital, the City School and Fine Arts Academy were all recorded,

along with many period buildings including the High Cross, in the ancient city. St Stephen's church was photographed from several viewpoints. He made at least one picture of an unusual geological formation; an almost-abstract view entitled *Contorted Strata below the Hotwells* which made a striking and unusual image.

Gutch visited the Somerset seaside resort of Weston-super-Mare just a few miles south-west of Bristol in June 1858. The town was rapidly developing and Gutch made a series of negatives there, including at least three views of the construction of the new town hall. He had made a few dull pictures in the two years previously and now returned to make a good set of negatives, including a study of workers in a limestone quarry and the rectory at Lympsham. Sir Thomas Kynfton and his wife Georgiana stand outside their recently extended residence at nearby Uphill Manor and two unknown couples pose in the grounds of Uphill Rectory, formerly the residence of poet Revd William Bowles (1762-1850). The poet had been a friend of both Coleridge and Gutch's father John Mathew Gutch.

In 1858 Gutch published a printed list offering 35 views of *Weston-super-Mare and Neighbourhood*, along with a dozen views of nearby Cheddar. The list comprised prints made from negatives taken both in 1856 and 1858. Single views were priced at two shillings, or a selection of 11 mounted in a drawing book, at one guinea. The photographs were available through Messrs. Palmer and Son, Music Sellers in Weston-super-Mare and Mr Weston, Bookseller in Corn Street, Bristol.

A SELECTION OF PHOTOGRAPHIC VIEWS, ILLUSTRATING THE Scenery of Weston-super-Mare & Neighbourhood, 1858.

Single Views, price 2s., Mounted on Cardboard; or in a Drawing Book, containing 11 and a Floral Title, £1 1s. Size, 6½ by 8¼.

Knightstone—Knightstone Baths—Claremont—Bristol and Exeter Railway and the High Bridge—Kewstoke Church—Worle Church—The Old Church and Vicarage, Weston—Old Church-at Uphill—Uphill Vicarage—Woodspring Priory—Ditto from the Orchard—Reeve's Hotel, from the Esplanade—The Esplanade—Whereat's Reading Rooms from the Esplanade—New Town-hall—Emmanuel Church—Villa Rosa—Overcombe—Uphill Castle—The Rectory, formerly residence of Bowles, the Poet, at Uphill—Hutton Church and Parsonage—Locking Church—Lympsham Church, and two views of the Parsonage—Banwell Church—Axbridge, the Church and Market-square—Wrington Church Locke's House at Wrington—Yatton Church—Backwell Church—Chelvey Church—Chelvey Rectory—Clevedon Court, Sir A. Elton's—Frankfort Hall, Clevedon, Mr. Finzel's.

CHEDDAR, SOMERSET.

A series of twelve Views, illustrating the Scenery of Cheddar.

May be obtained of Messrs. PALMER and SON, Music Sellers, Weston-super-Mare; and Mr. WESTON, Bookseller, Corn-street, Bristol.

A published list of Gutch's views of 'Weston-super-Mare and Neighbourhood'

It is not clear what made Gutch decide to photograph every church in Gloucestershire; it may have started as a religious mission or even as a semi-commercial undertaking. He had already made studies of several churches in Somerset, central Bristol and south Gloucestershire in 1858 and this perhaps formed the nucleus for a collection of views.

Only a character like Gutch could contemplate such an undertaking; it was a mammoth task to record every church building and chapel. The logistics were daunting; transport was slow and uncertain and the roads were poor. He had the task of carrying his heavy camera and chemicals, finding a good viewpoint and dealing with difficult

locals. The weather that summer was very hot and would have added to his disability. He may have used a regular assistant, or relied on a daily hired coachman for help in his quest.

He was encouraged in his task by several members of the local clergy, including the Honourable Charles Baring (1807-1879) who had become Bishop of Bristol and Gloucester in 1856, replacing James Henry Monk (1784-1856). Monk was a former tutor to Fox Talbot when he was at Cambridge and it was Monk who later offered Revd George Bridges a position as his private secretary, along with a rural living, when he returned to Britain in 1852. Gutch also knew the photographic pioneer Bridges and photographed him at Beachley rectory near Chepstow in 1856. Perhaps it was Bridges who encouraged Gutch to make a record of all the churches in Gloucestershire. Bishop Baring had helpfully agreed to purchase a photograph of each church within his diocese and Gutch mentions the kindness of other leading clergy who supported his project; whether or not they all supported him financially is uncertain. The undertaking must have been a drain on Gutch's limited resources.

The spring arrived early in 1859 and Gutch was in a poetic and religious frame of mind when he tentatively announced, through the pages of *Photographic Notes*, that he had decided to record all 500 churches in the county of Gloucestershire. He softened the blow to his readers of this less than exciting news by quoting from no fewer than four romantic poets in his first essay of the year.

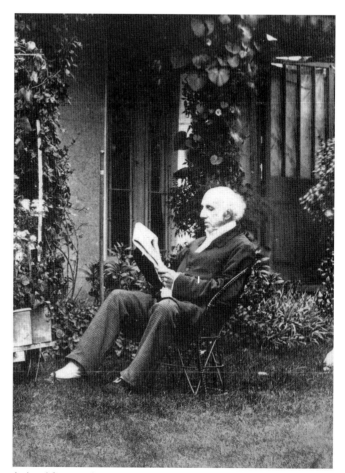

A detail from a photograph by Gutch showing Revd George Bridges at Beachley Rectory

Under the alliterative title *Positive Pictures taken from the Camera of a Peripatetic Photographer in Search of Health and the Picturesque*, 1859, Gutch describes his own reaction to the year's early awakening:

Of all seasons of the year it is, and ever has been to me, the most delicious; the awakening of nature from her winter's sleep. And I would maintain that no photographer, if he is a true lover of his art, can be otherwise than a true lover of nature, if at least he opens his heart and reads with an understanding and teachable spirit the lessons that are everywhere to be found, in his wandering and searching after the picturesque, whether by the sea shore, – and savage rocks, – the mountain torrent, – rustic bridge, – or green hedge-row, – in all and each, and every page, of nature's book, there is a moral pointed – a lesson to be learnt, – and a finger silently pointed upward, to the all-good and all-wise being, who has so wonderfully assisted the beauties of this lower world, and offered them to us for contemplation and instruction, – a book replete with wisdom if we would only turn over its pages.

Gutch had already photographed many rural Gloucestershire and Bristol churches before 1859. Now he felt committed to make at least one view of each, irrespective of its merits. He published a single-page document outlining his plans entitled: *Prospectus of a Proposed Series of Photographic Delineations of the Principal Churches in the Diocese of Gloucester and Bristol.*

The first church that he tackled in April 1859 was at what was then genteel Westbury-on-Trym, just over the Downs from Clifton, where he was probably staying with friends. In *Notes and Queries* Gutch had appealed for readers to send information regarding choice Gloucestershire churches to him at 10, Upper Victoria Place, Clifton. The church in the smart suburb of Henbury was next on the list:

> A few miles further on brings the visitor to the aristocratic little village of Henbury, the view from Henbury Hill gives the idea of the manner in which the suburban citizens of Bristol live. The neat and elegant villas that peep out amongst the plantations on all sides, reminding one of roast beef and real comfort. There seems nothing in a state of nature there; every thing about the village is trained to look exclusive and aristocratic; the walks are cleanly tended, and the hedged trimmed to highest state of precision.

Gutch subsequently photographed the nearby Harford alms houses, admired the ancient elms in the area and recommended April as being the best month for photographing trees. On 30 April 1859 a great fire engulfed the sugar house at Fuidge and Fripp's refinery in central Bristol and Gutch made a dramatic news picture of the conflagration.

In his second *Photographic Notes* essay, published in July 1859, Gutch justifies his decision to remain in the West Country and re-acquaint himself with its photographic possibilities. However, in a further essay published in November, he admits that the churches of Gloucestershire had begun to bore him and despairs at the sameness of the square, squat towers of churches around Gloucester.

He had also become irritated by the children who flocked around to stare at 'the man who is going to take the likeness of the Church', as soon as the camera was unpacked. The summer of 1859 had been unusually hot and on many days the heat was overpowering, although Gutch, unlike many others, seems to have had no problems with the temperature affecting his photographic chemicals. To recover his enthusiasm Gutch took a well-earned two-week break in London to attend the Handel Festival that marked the centenary of the composer's death:

> A fortnight's holiday, to be present at the Handel Festival in London, freshened us up for the more arduous task that awaited us in taking the churches around Gloster. This place was fixed upon from the great convenience of the railroads and canal boats: and the churches in and around are very numerous and thickly dotted, tho' alas, not of the most interesting kind.

With a refreshed Gutch back behind the camera Gloucester Cathedral merited eight negatives, but he had trouble finding a spot that gave a good general view. Some years earlier Roger Fenton had made a view of the cathedral from a nearby church tower. Gutch, however, was not impressed describing Fenton's study as 'by no means one of his happiest efforts.' Because of his infirmity, JWGG was not inclined to venture up the same tower himself. He attempted to photograph the cathedral's gloomy cloisters, but failed 'from want of light'. In a less salubrious setting Gutch describes his shock at seeing a pig in the churchyard at Norton, near Gloucester:

> I was not a little disgusted at the active operations of a pig, allowed to roam at large and grub up the grass 'ad libitum'. I directed the attention of the cottagers close by, but they said 'it was no business of their's, and cows and pigs were allowed to come in whenever they pleased.'

Perhaps it was the pig, the hot weather or the sameness of the structures that put him off, but after five months of almost constant photography of churches Gutch was not surprisingly tiring of his self-imposed task. He had managed to portray well over 200 Gloucestershire churches and chapels, a considerable achievement. In the 15 November 1859 edition of *Photographic Notes* he longs to return to more familiar fare:

> I have for this year closed up my ecclesiastical tour; and for the remainder of the photographic months I shall hope to accomplish work of a more miscellaneous description; and, sooth to say, more to my own tastes – coast scenery, ruined abbeys, and picturesque roadside scenery.

Gutch had had his fill of churches by September and made Tenby in west Wales his final photographic destination for

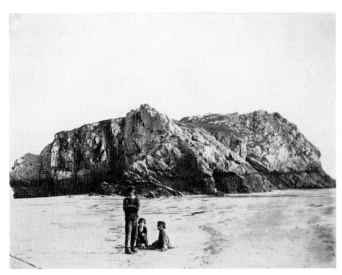

St Catherine's Island, Tenby, Wales. Photographed by Gutch in 1859

1859. It was easily accessible; a steam-packet visited the harbour from Bristol two or three times a week. Only a few views from Tenby survive; he may not have completed his usual quota; perhaps he was taken ill or simply the majority of images he made there have been lost. One good study shows a group of boys in front of St Catherine's Rock at low tide. The series was to be the last photographic essay that Gutch undertook. Seven studies from the Tenby series are preserved in the J. Paul Getty Museum and one in the Wilson Centre of Photography collection.

Gutch continued to correspond with *Notes and Queries* about a wide range of topics, including photography, until June 1860. His correspondence included the formula for Coathupe's writing fluid (Gutch swore by the home-made ink, invented by his friend from Bristol some 20 years earlier). Wearing his botanist's hat he replied to a correspondent who was seeking the proper botanical name for the lilac. The chemical composition of fly-papers was discussed. The colour of university hoods was another arcane topic; as was the correct length of Westminster Hall. The shortest entry was Gutch's reply to a query about the number of extant portraits of the artist J M W Turner; Gutch listed just three.

Gutch's final exhibited work was shown at the Photographic Society's London exhibition that opened in January 1861. The eight pictures displayed were all old work from 1856-58. A few of Gutch's West Country friends were also represented at the 1861 exhibition, including Baynham Jones from Cheltenham and John H. Morgan and Thomas Cadby Ponting, both from Bristol.

John Wheeley Gough Gutch died in London on 13 April 1862 at 38 Bloomsbury Square. He was 53. The cause of death was given as albuminuria and an abscess in the kidneys. His wife Elizabeth Frances died at Arthur's Tower, Knightstone, Weston-super-Mare on 27 September 1869, aged 57, from heart failure.

53

Malvern and district

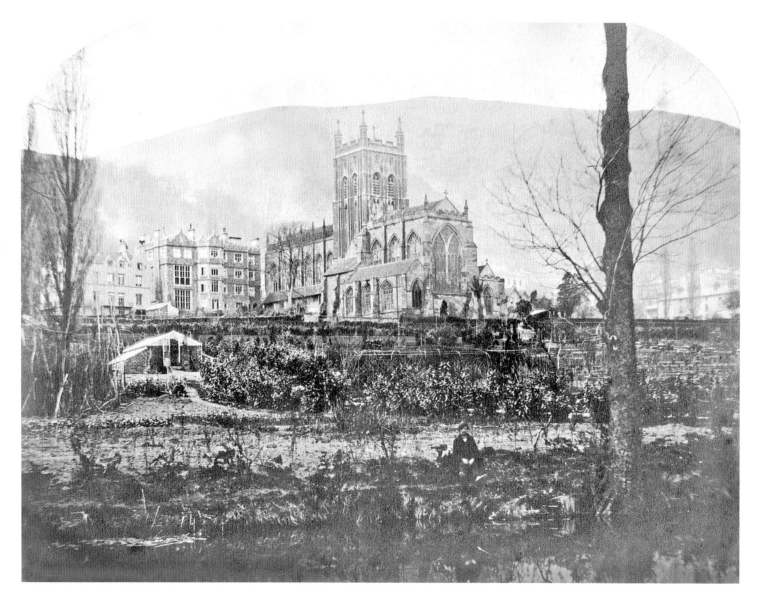

The Abbey from Swan's Pool.

Note: throughout the plates, the captions in italics are Gutch's own. All landscape photographs are salt-prints from whole-plate negatives (approx 6.5 x 8.5 inches). The portraits are mostly from half-plate negatives.

The Abbey Churchyard.

The Abbey Churchyard.

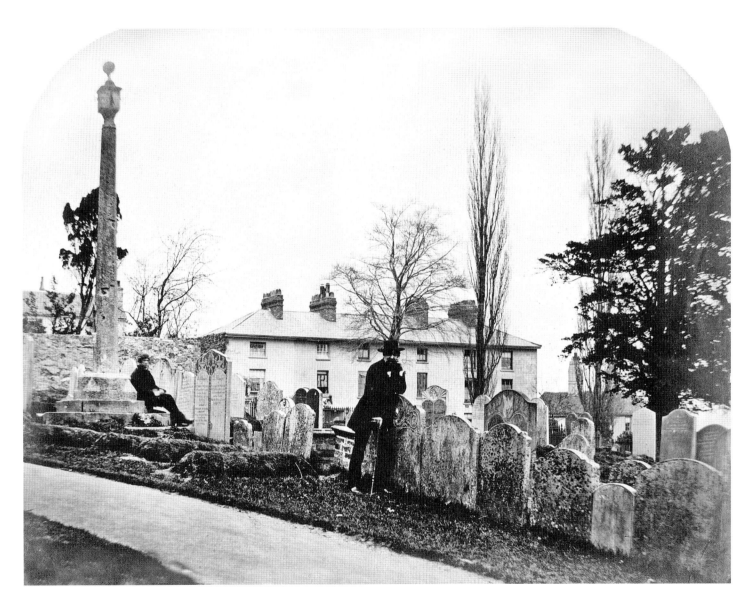

The Abbey Churchyard.

The Abbey Gateway from Dr Wilson's.

The Swan's Pool.

The Swan's Pool.

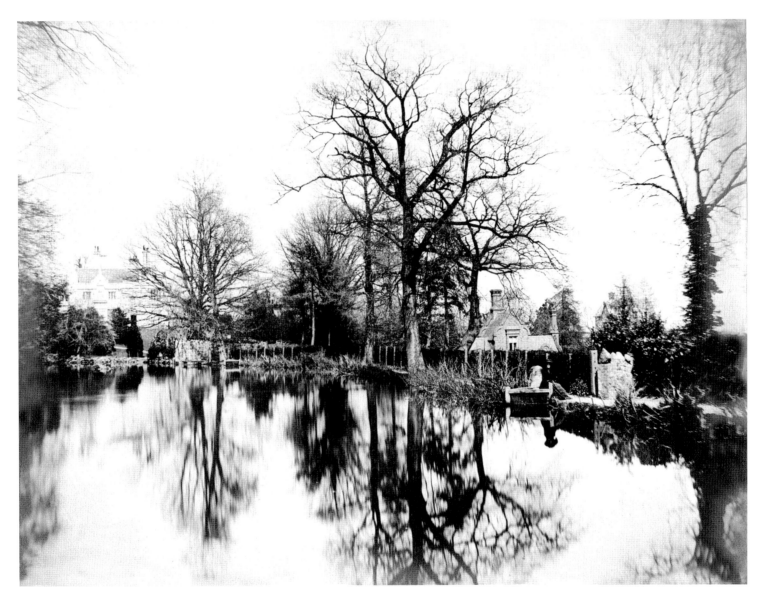

Dr Gully's House and Douche Baths from the Swan's Pool.

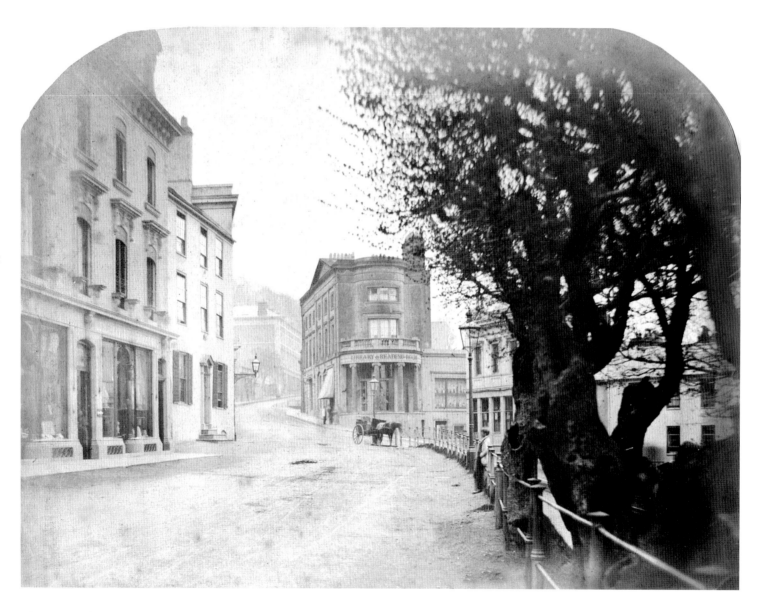

The Library from opposite the Belle Vue.

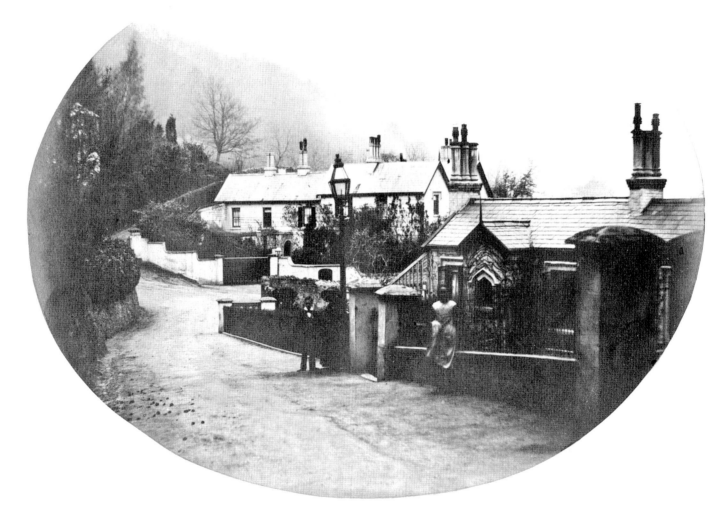

63

Albert Villa (Mrs Munning's).

64

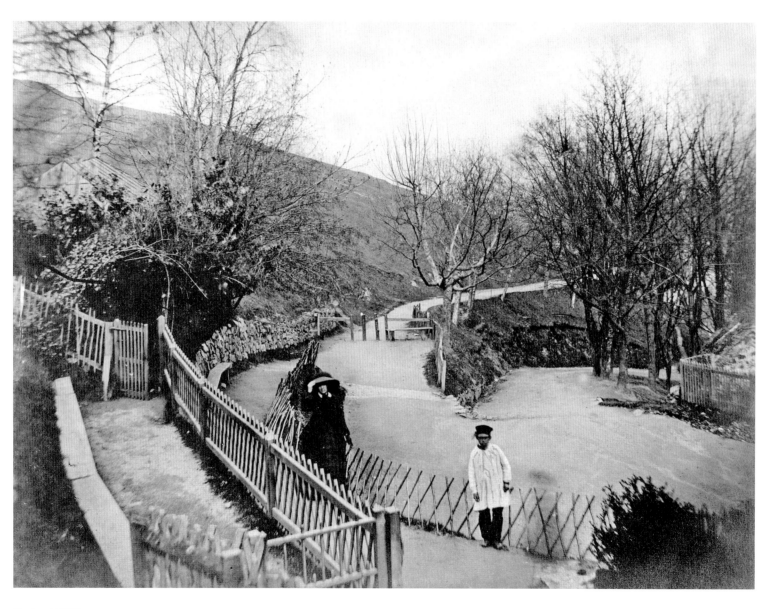

St Ann's Well.

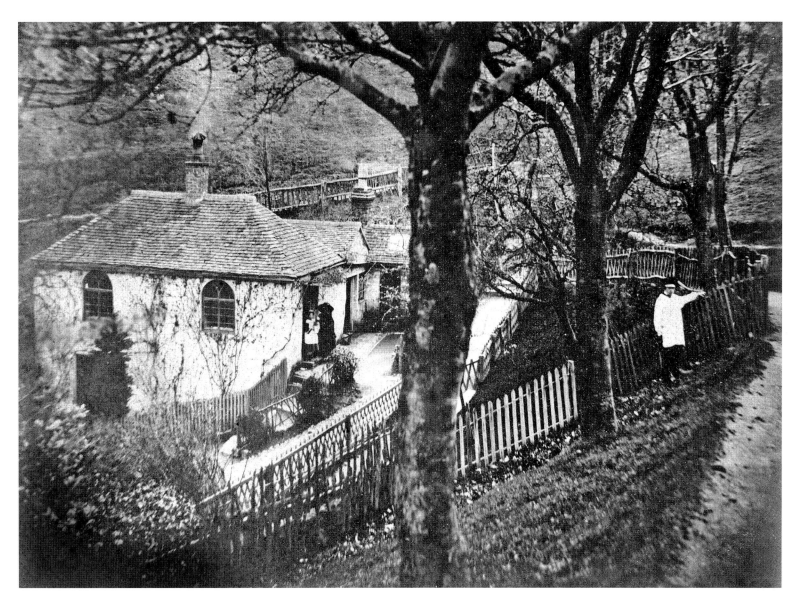

St Ann's Well.

The Priory (Dr Gully's).

Old houses near Holyrood Terrace.

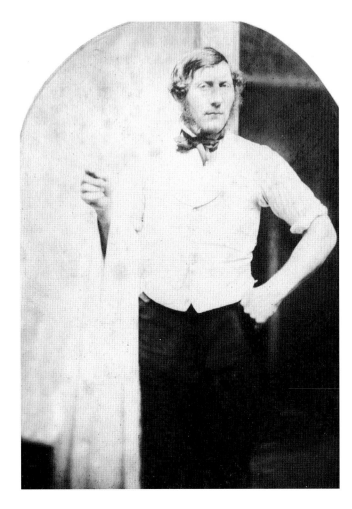

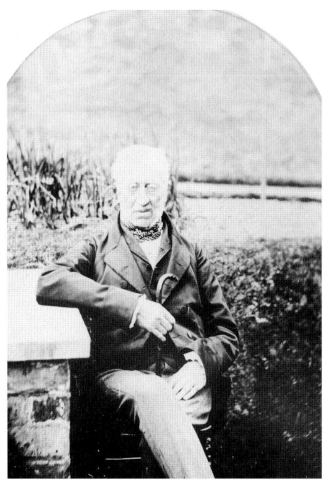

My 'Bathman': W. Groves.

W. West.

'The Bathman at Home'.

Mrs Godsall & sister, Graffenberg House.

The Devil's Oak.

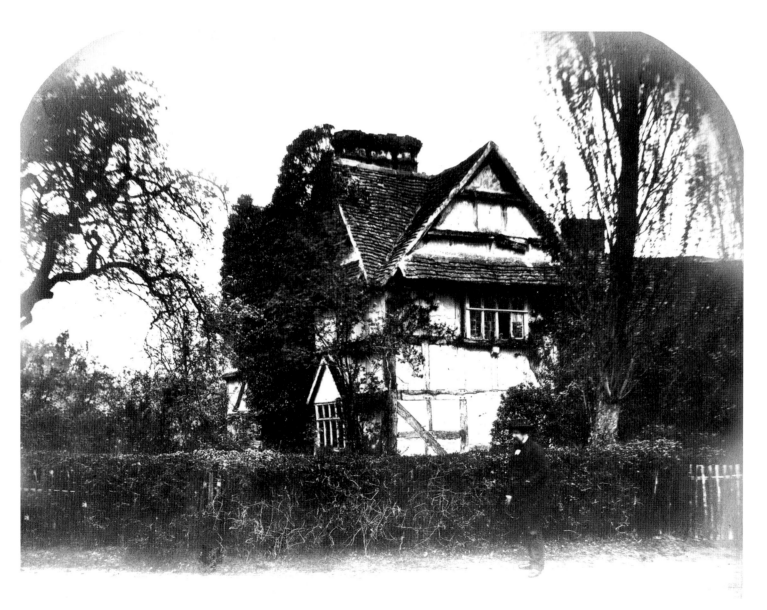

Pickersleigh House.

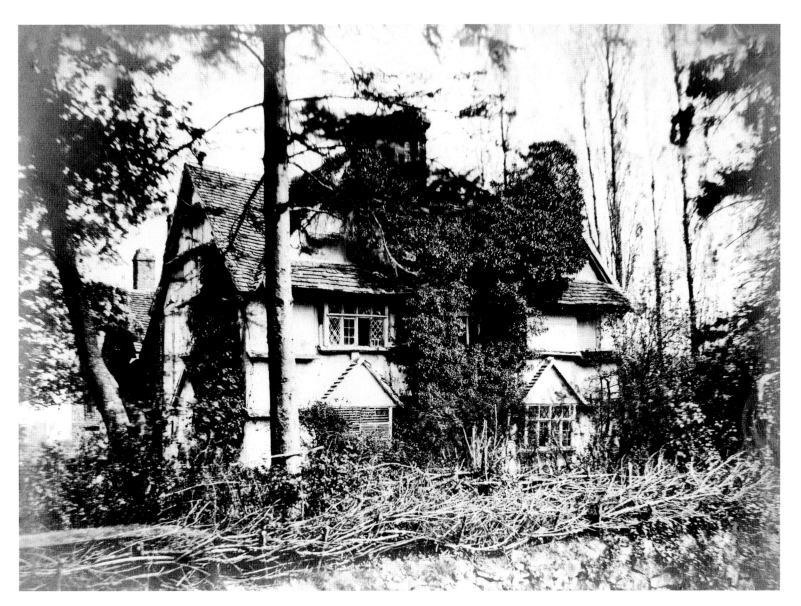

Pickersleigh House.

Lane near Pickersleigh.

Newland Church.

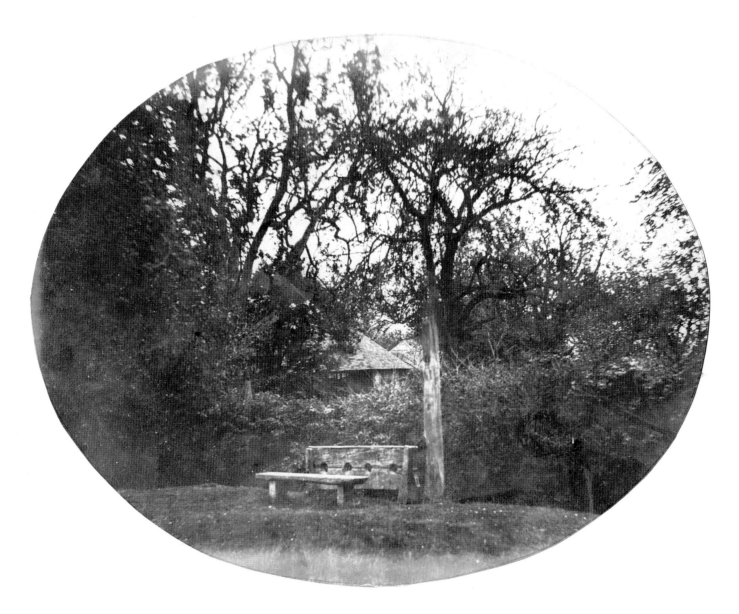

The stocks at Newland.

Street in Bosbury, Herefordshire.

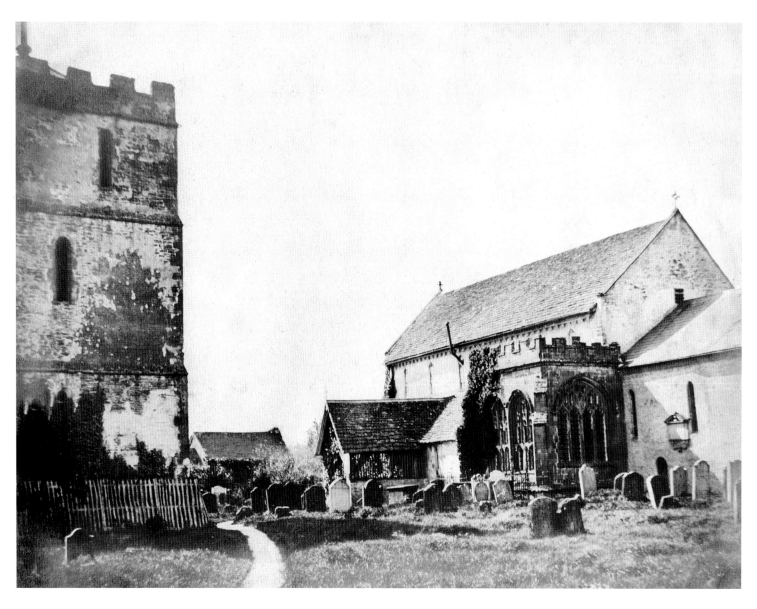

Bosbury Church.

The 'Holywell', Little Malvern.

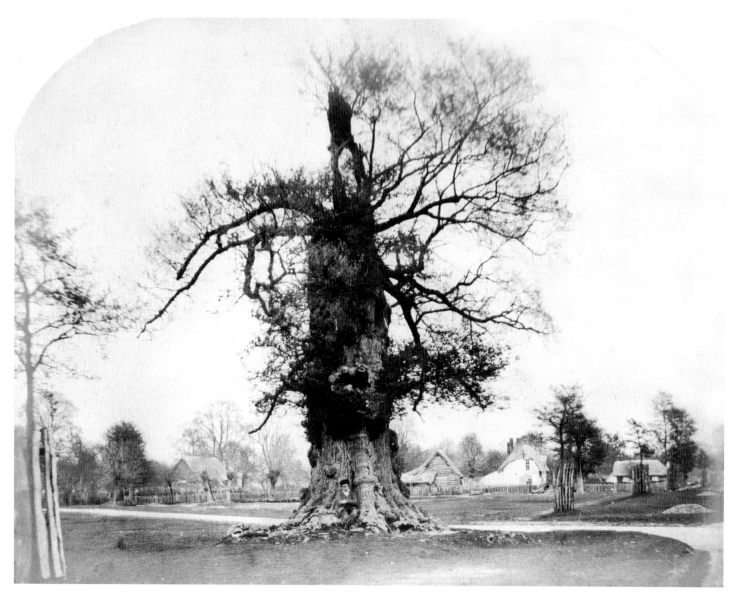

The Old Elm Tree. 'Middle Elm', Barnard's Green.

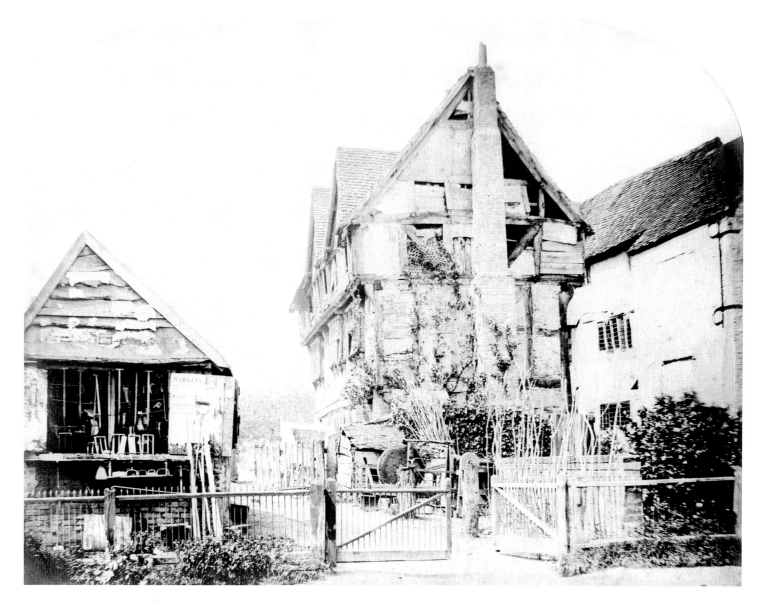

Old house at St Johns near Worcester.

Common Hill.

Barbourne near Worcester.

The West Country

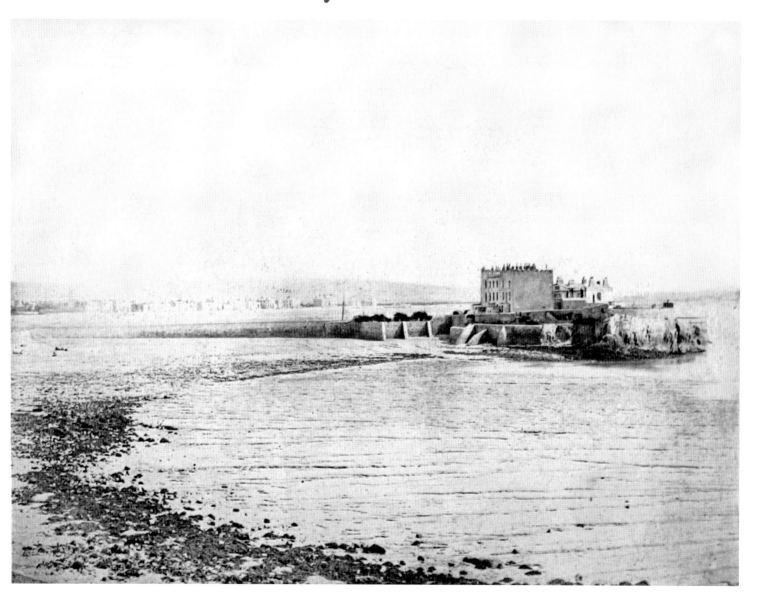

Knightstone Baths, Weston-super-Mare.

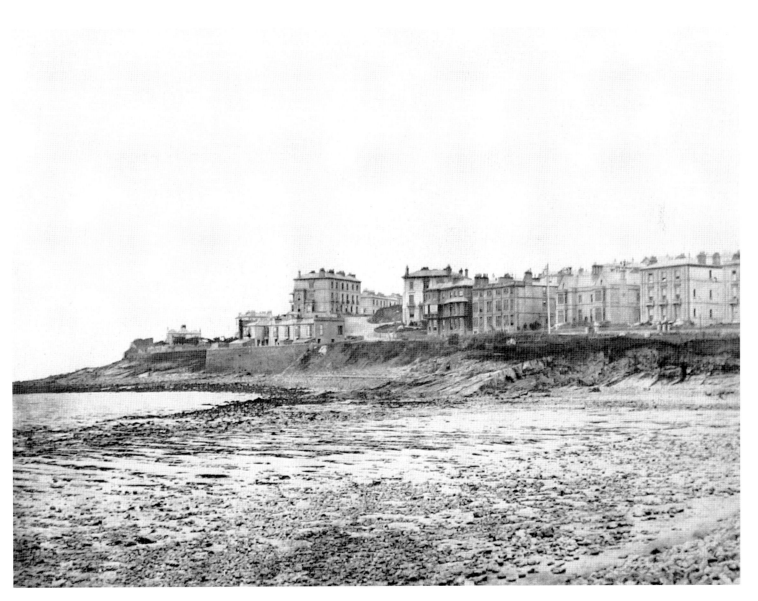

Clermont, Weston-super-Mare.

Emmanuel Church, Weston-super-Mare.

New Town Hall, Weston-super-Mare.

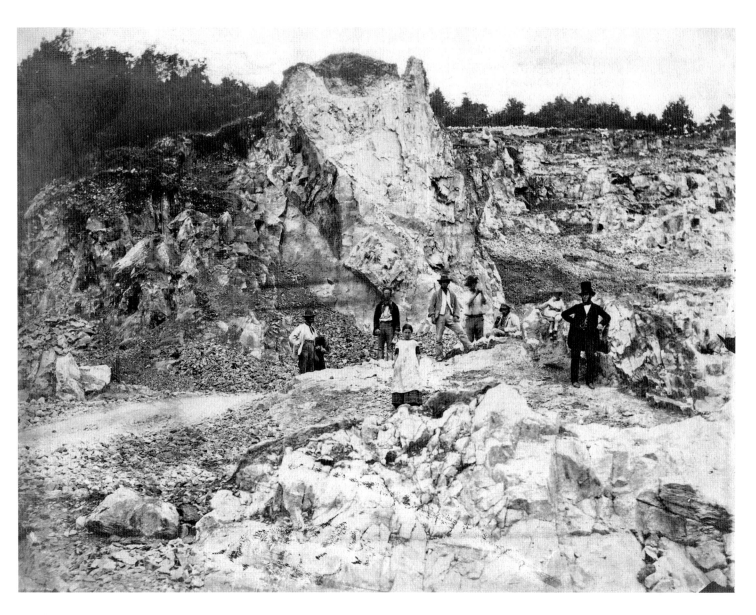

Limestone Quarry, Weston-super-Mare.

Uphill Rectory, formerly the residence of Bowles the Poet.

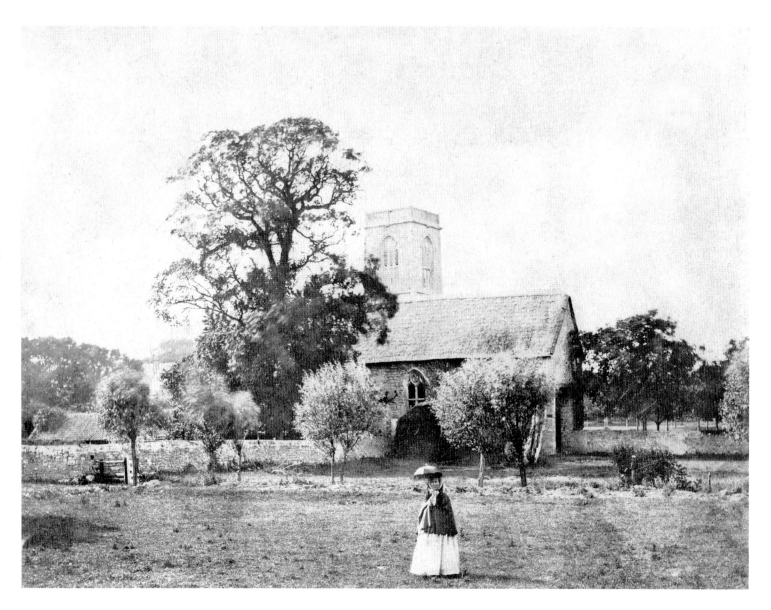

Woodspring Priory near Weston-super-Mare.

The Rectory, Lympsham, the Rev Mr Stephenson.

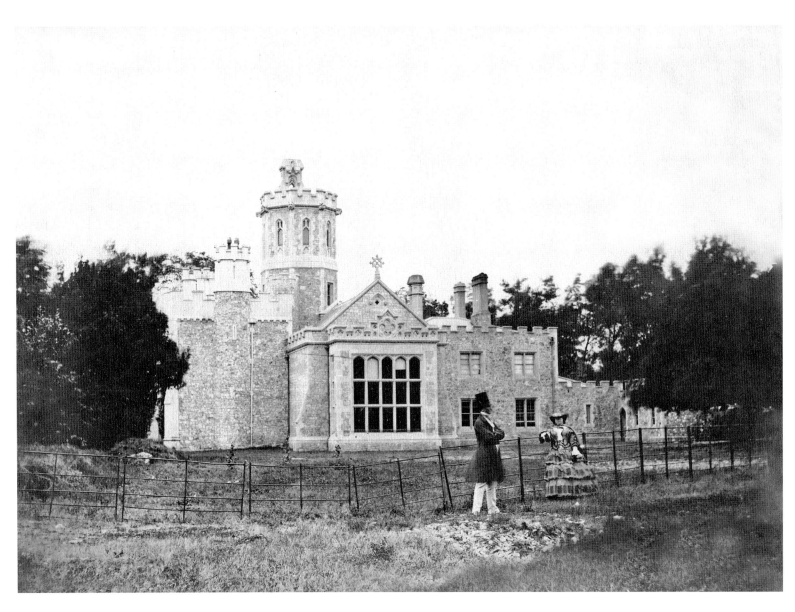

Uphill Castle.

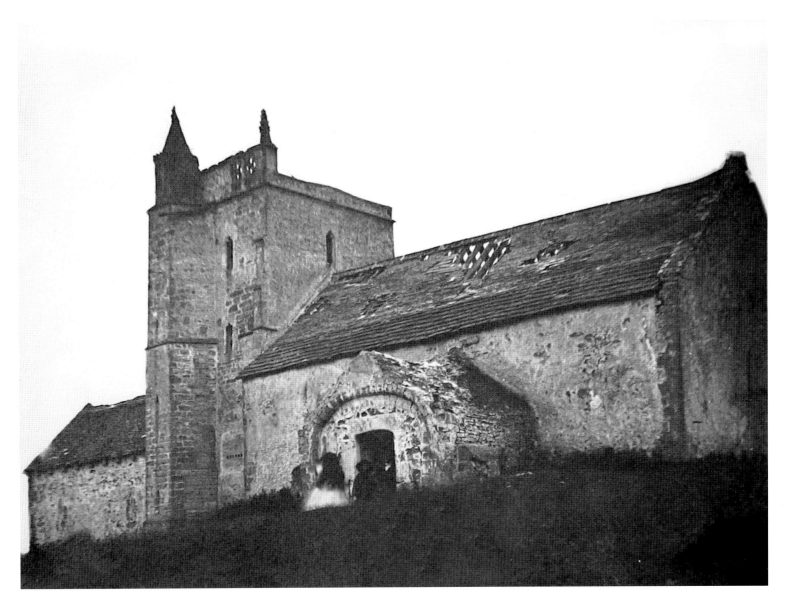

Old Saxon church at Uphill.

94

Clevedon Court.

Cottage in Cheddar Gorge.

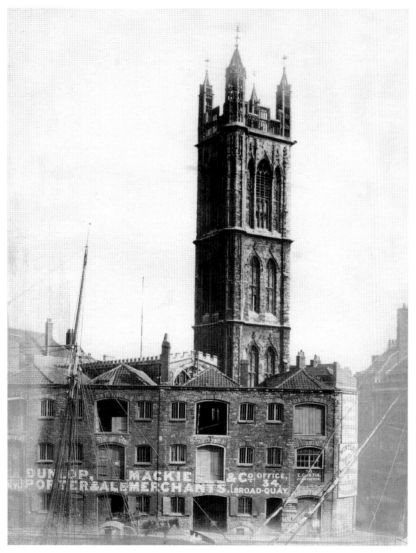

St Stephen's Church and warehouses, Bristol.

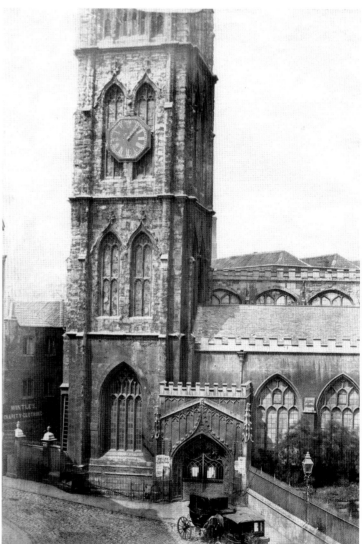

St Stephen's Church and carriages, Bristol.

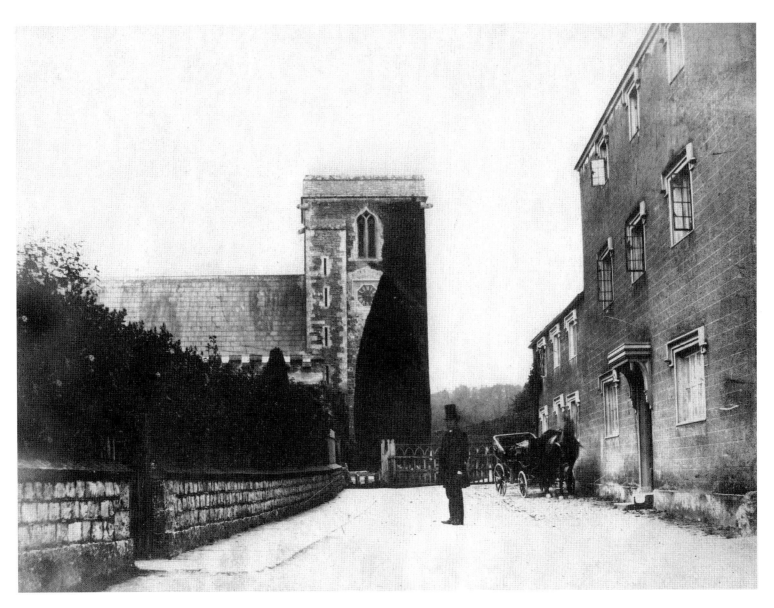

Henbury Church, Bristol.

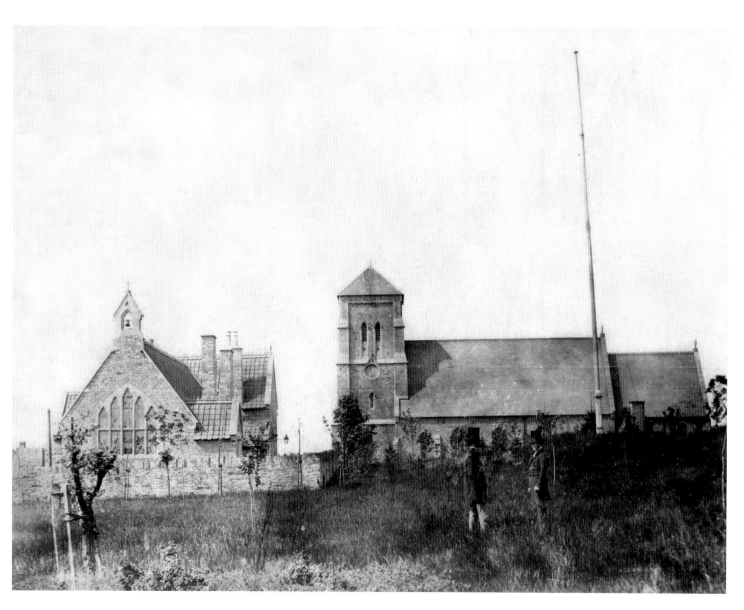

St Michael's Church, Two Mile Hill near Bristol.

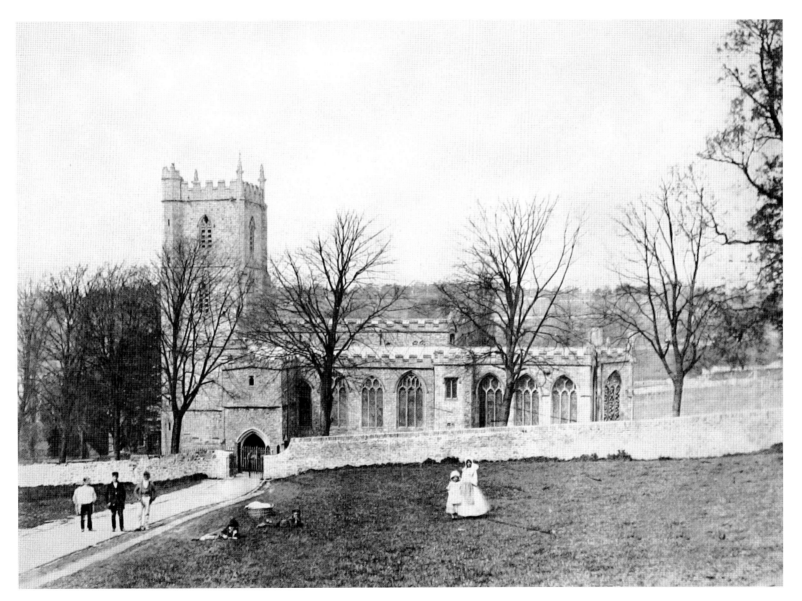

Westbury-on-Trym Church, Bristol.

Bristol Fine Arts Academy (later Royal West of England Academy).

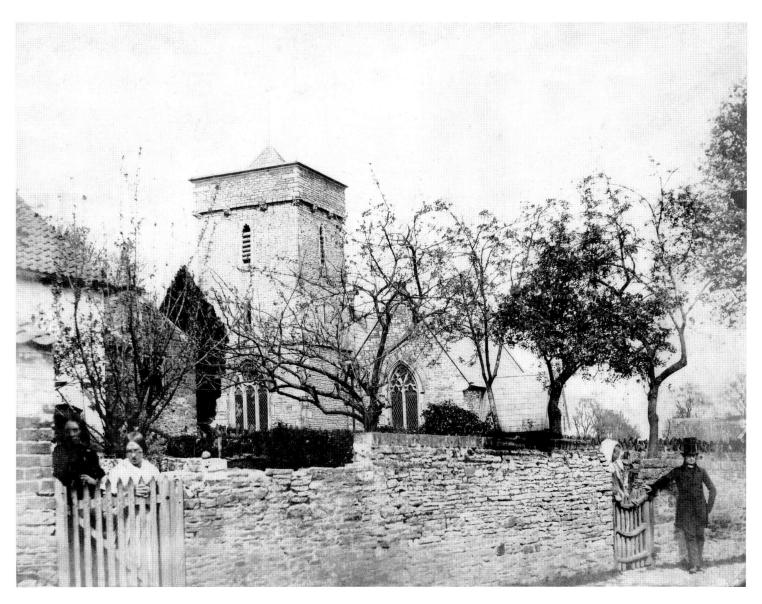

Filton Church, Bristol.

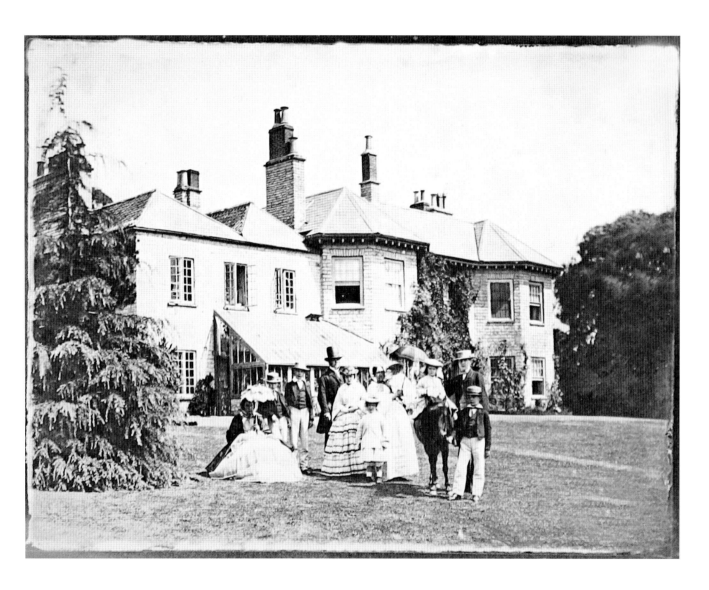

Bitton Rectory near Bristol.

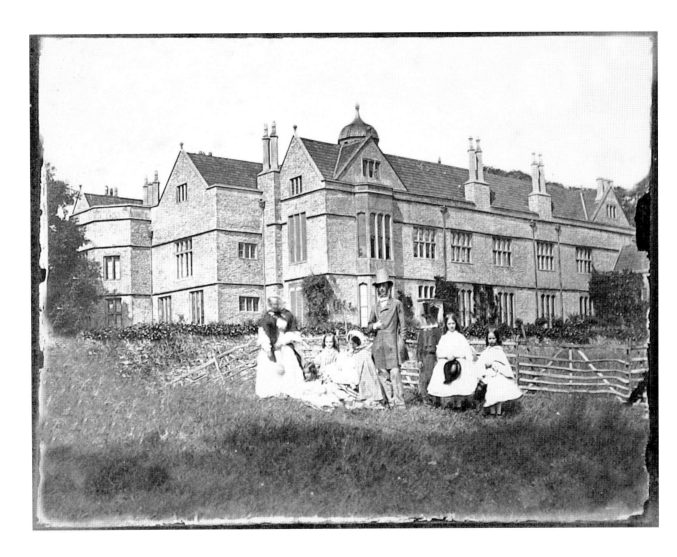

Dickenson family at Siston Court, Gloucestershire.

Revd George Bridges at Beachley Rectory near Chepstow.

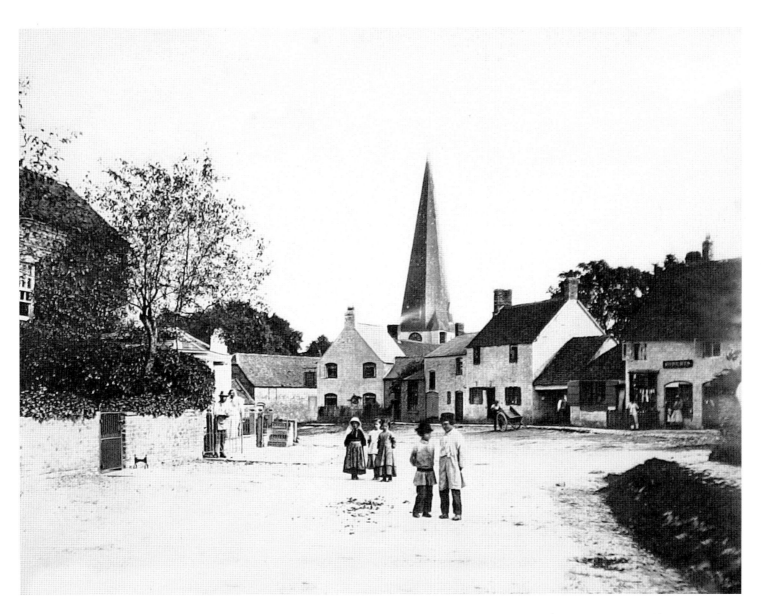

Westbury-on-Severn, Gloucestershire.

Lynmouth

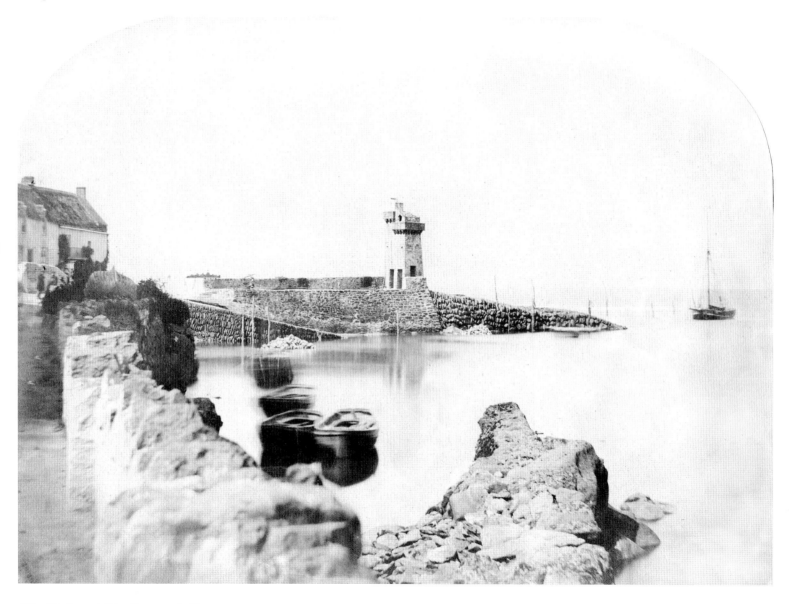

The Harbour & Pier, Lynmouth, Devon.

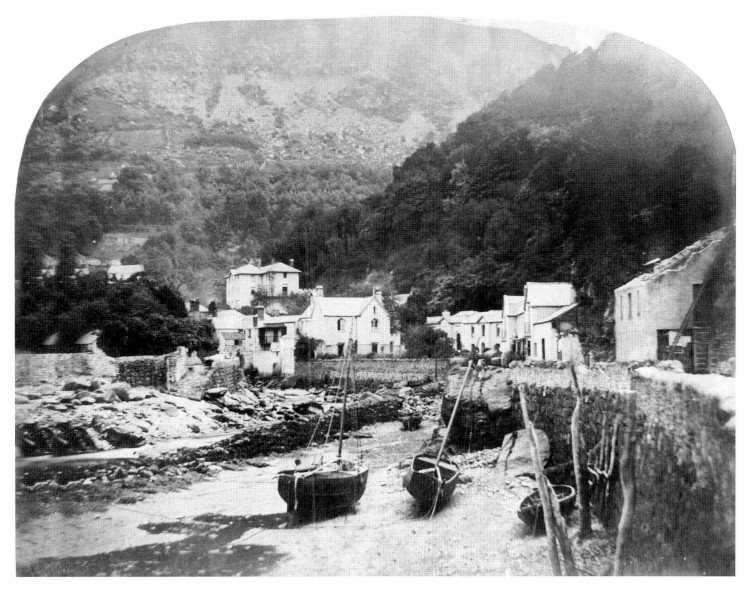

The Harbour, Lynmouth, Devon.

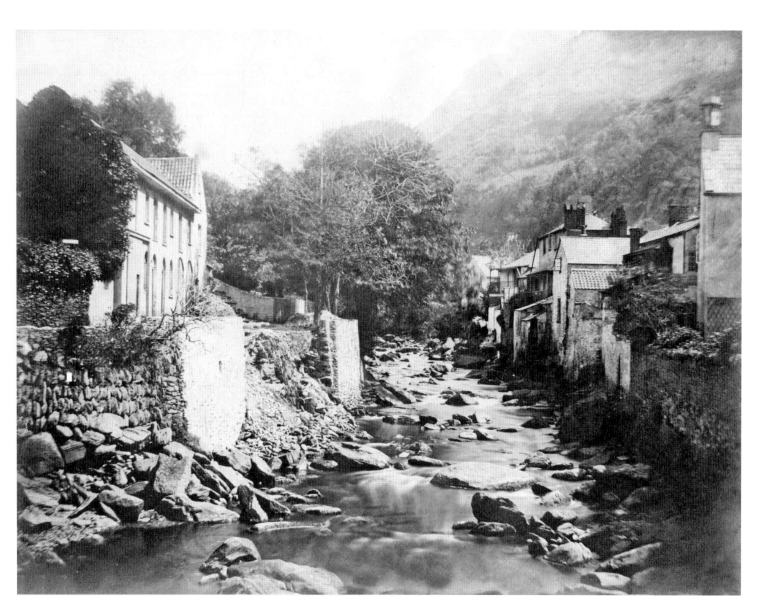

Lynmouth, Devon.

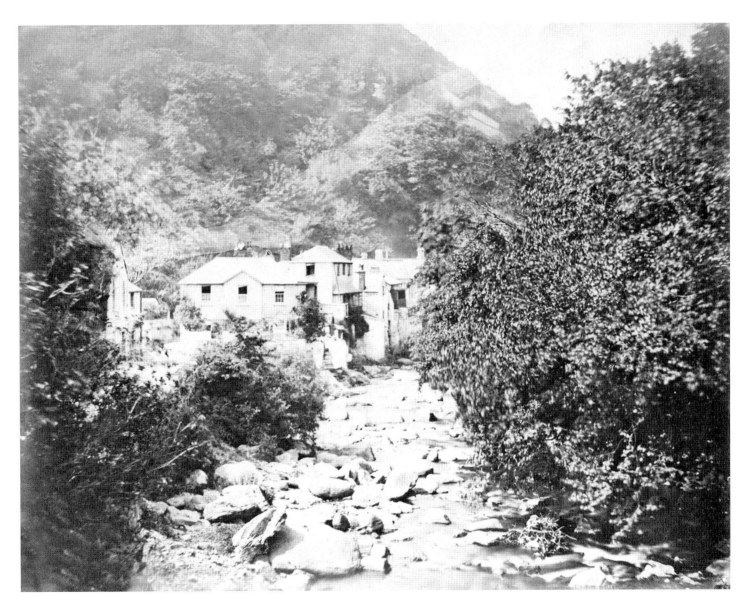

Lynmouth from the bridge near the Lyndale Hotel.

The Harbour, Lynmouth, Devon.

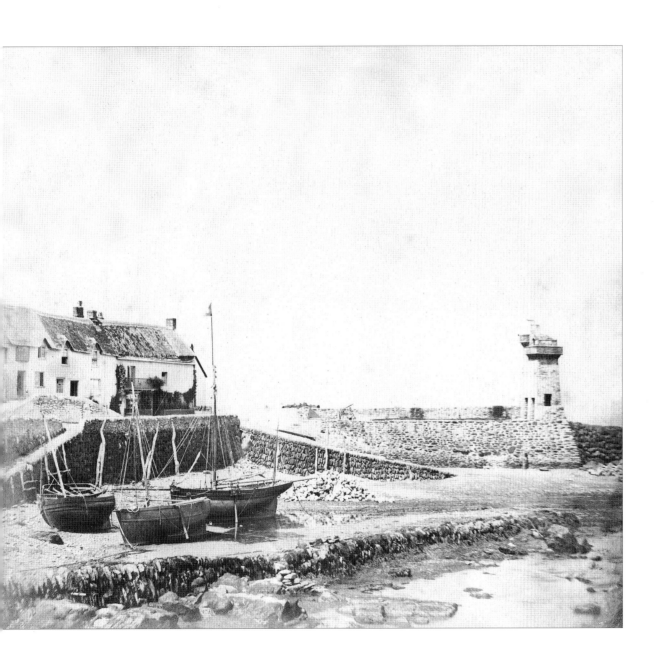

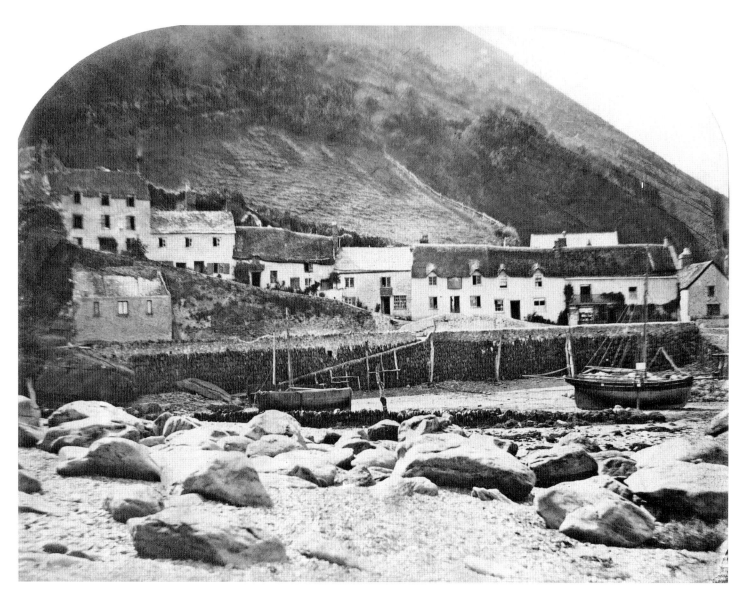

The Rising Sun Public House, Lynmouth.

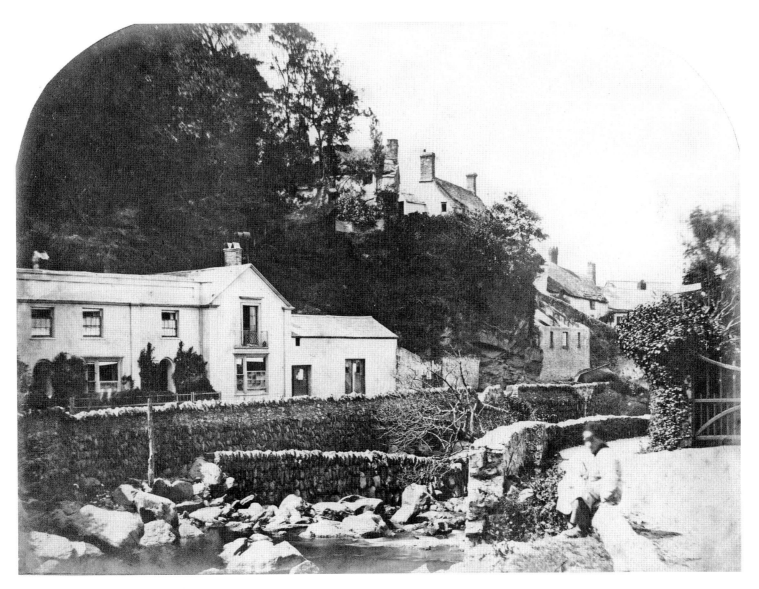

Lyndale House, Lynmouth.

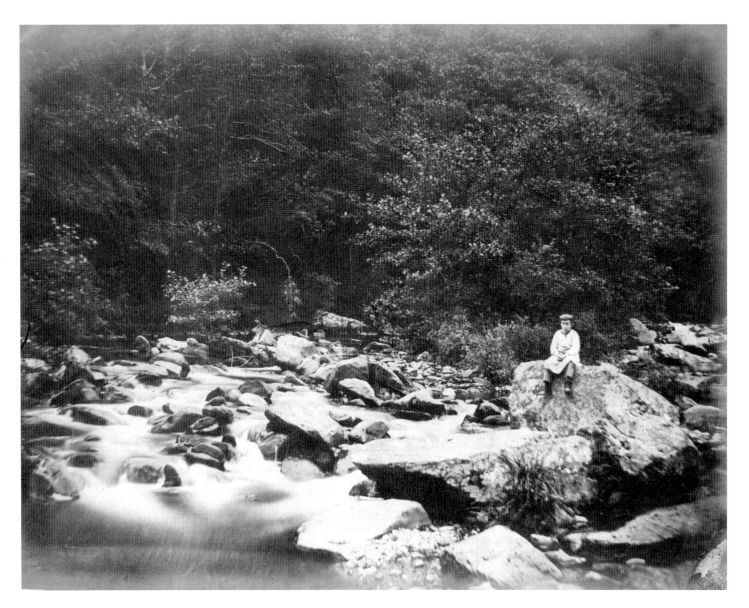

On the East Lyn, Lynmouth.

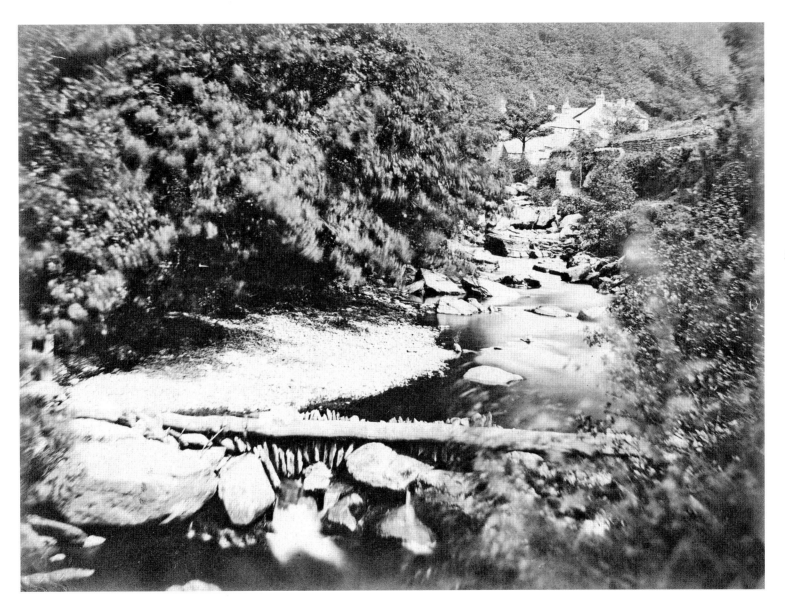

The weir on the East Lyn.

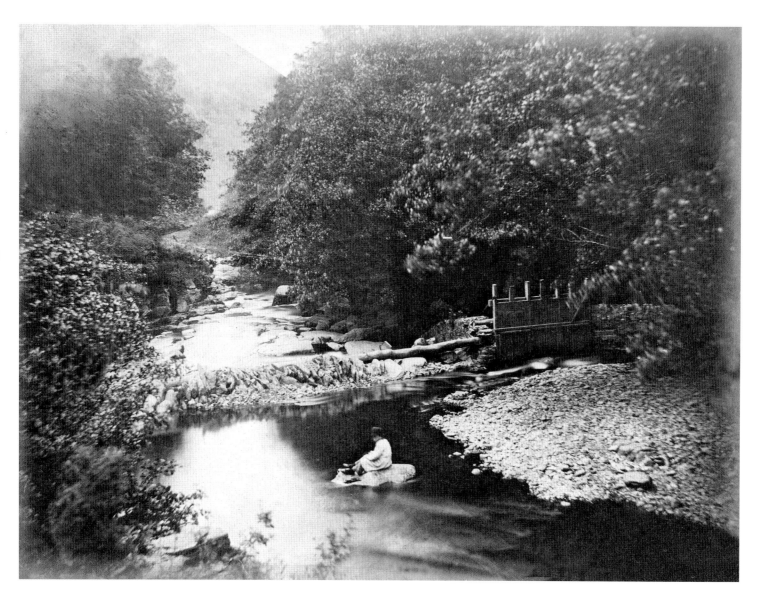

On the East Lyn, Lynmouth.

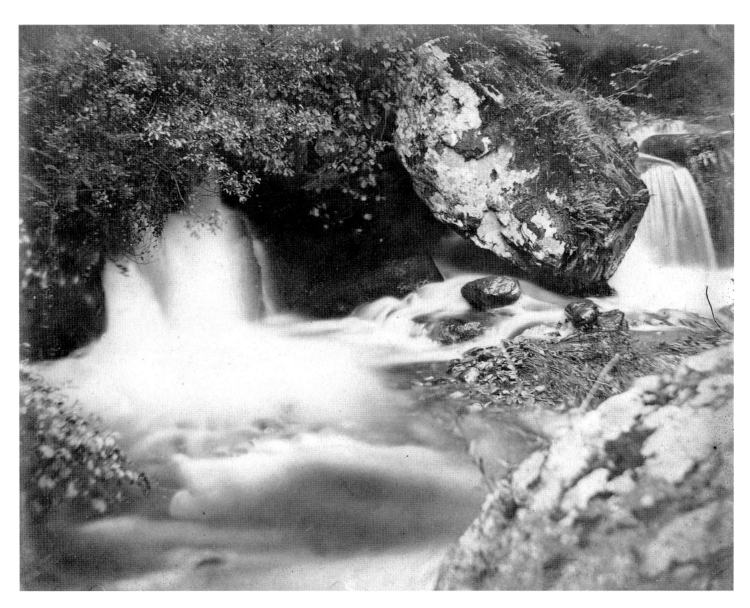

On the West Lyn in Sir W. Herries' grounds.

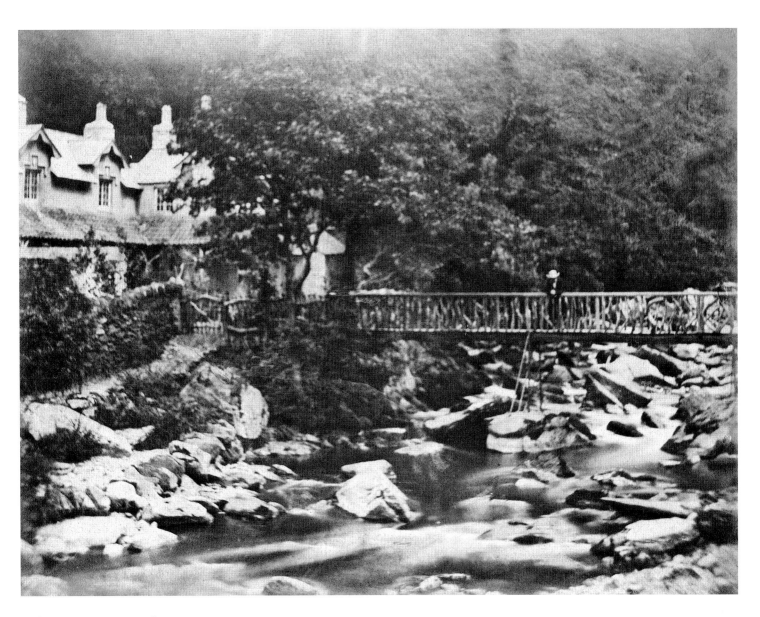

On the East Lyn, Lynmouth.

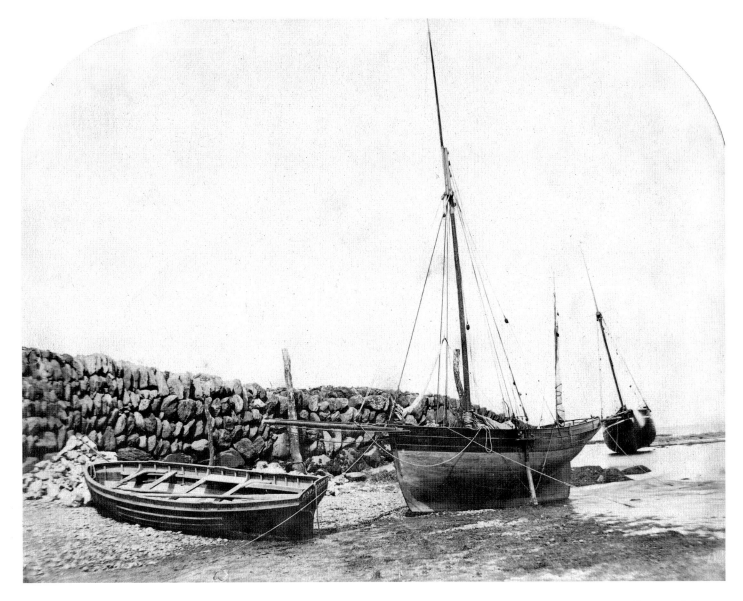

Lynmouth, Devon.

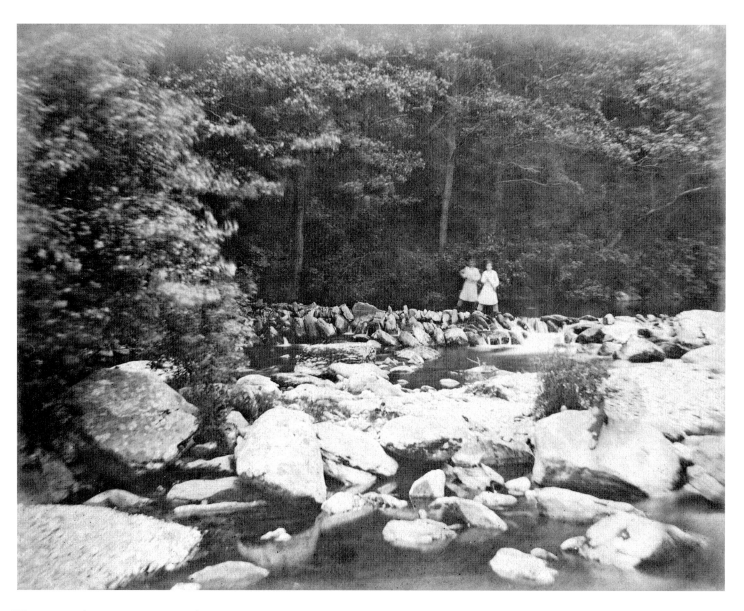

The weir on the East Lyn, Lynmouth.

The Tors, Lynmouth.

The pier and foreland, Lynmouth.

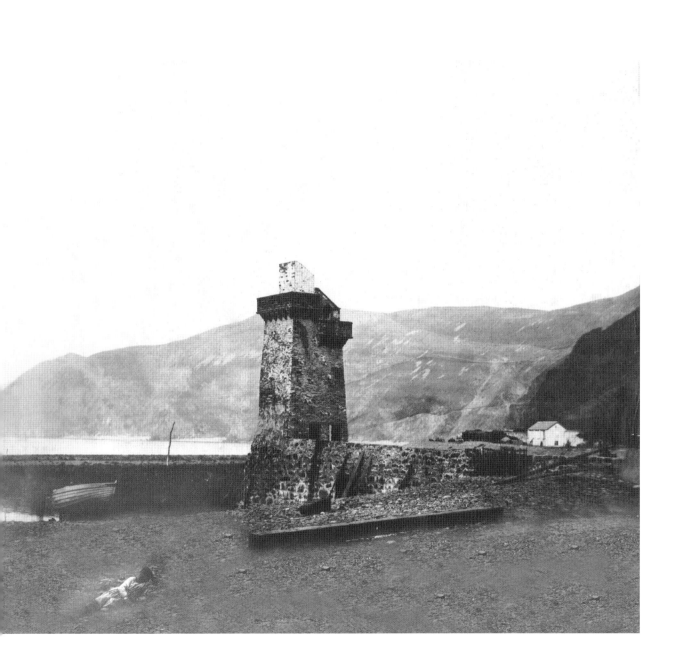

124

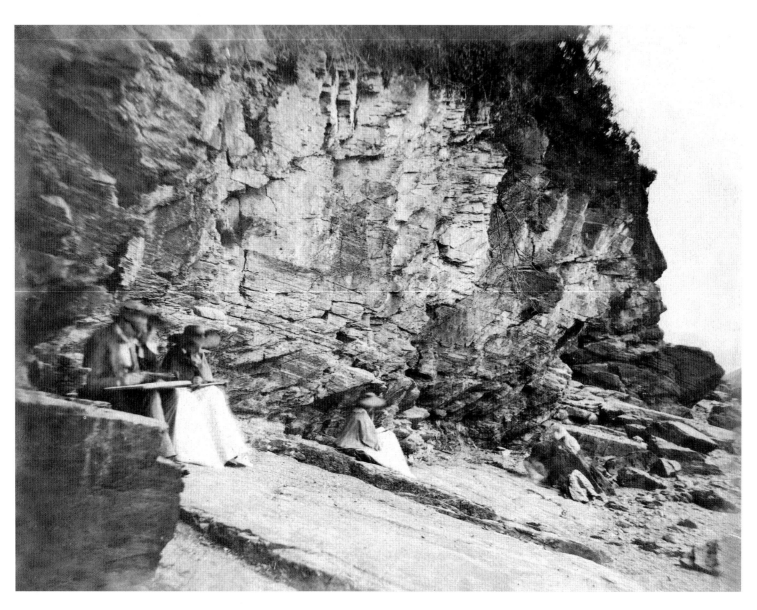

Lynmouth, Devon.

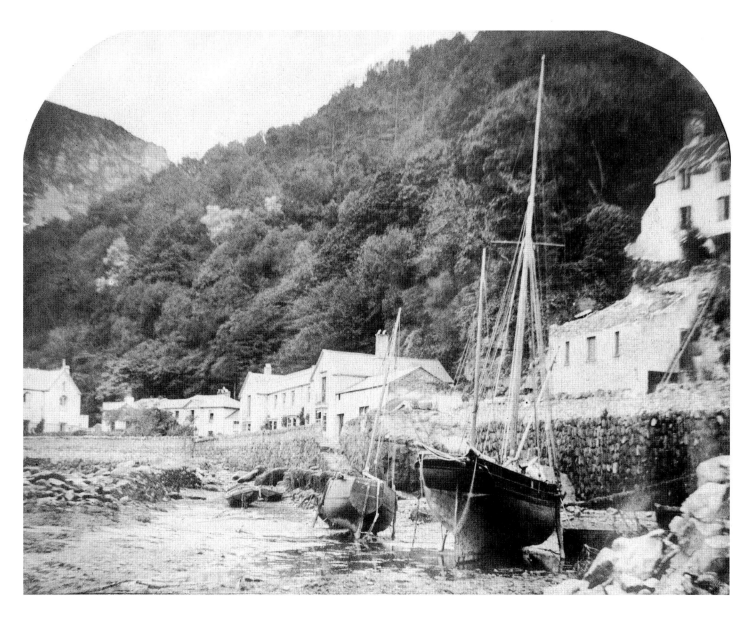

125

Lynmouth, N. Devon.

Penzance and West Cornwall

View of Penzance from the Harbour.

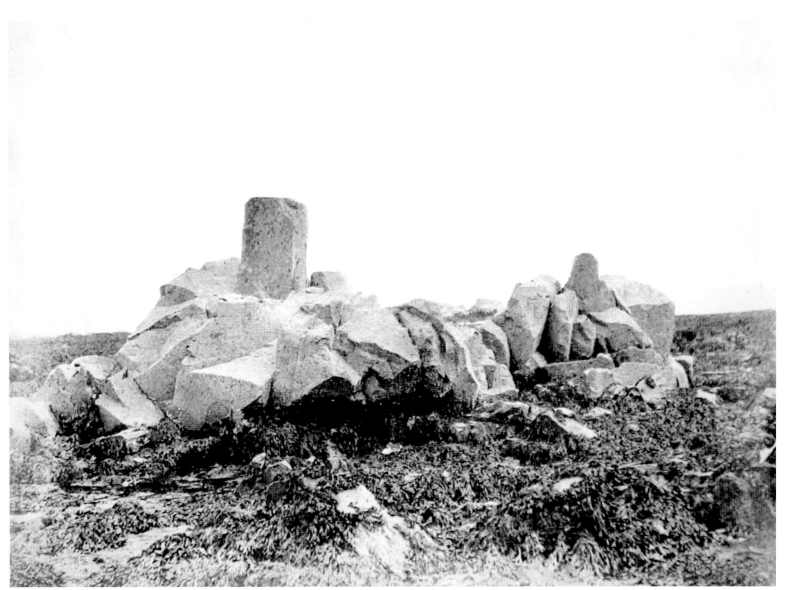

Group of porphyritic rocks, Penzance.

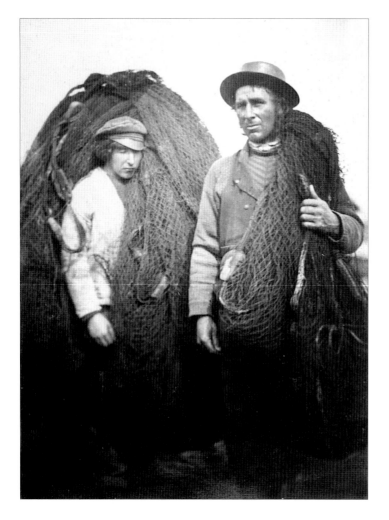

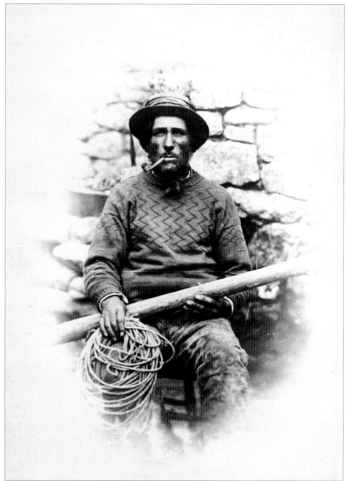

Pilchard fishermen, Penzance.

Boatman, St Michael's Mount.

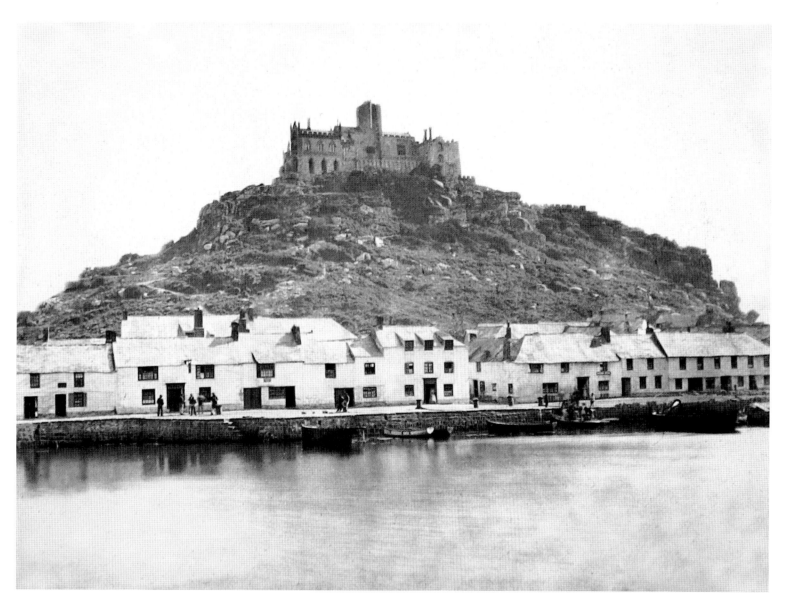

St Michael's Mount, from the Harbour.

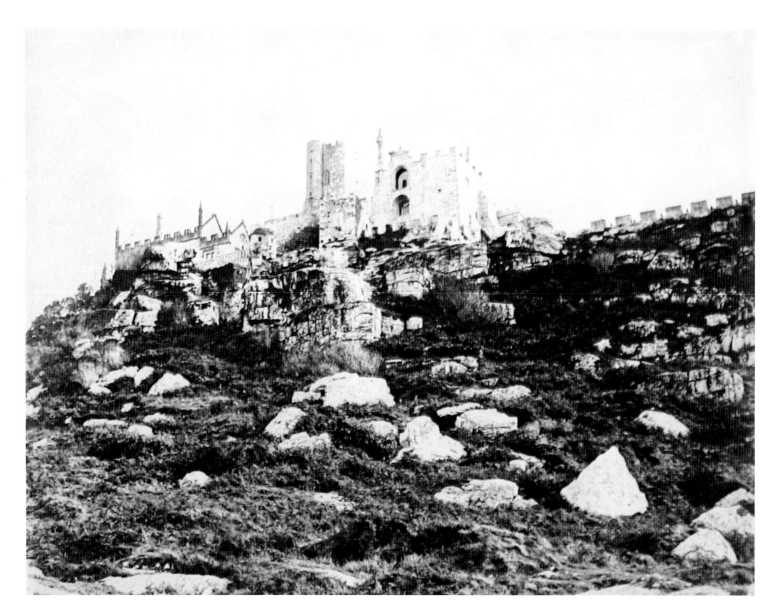

The Castle, St Michael's Mount, from the east side.

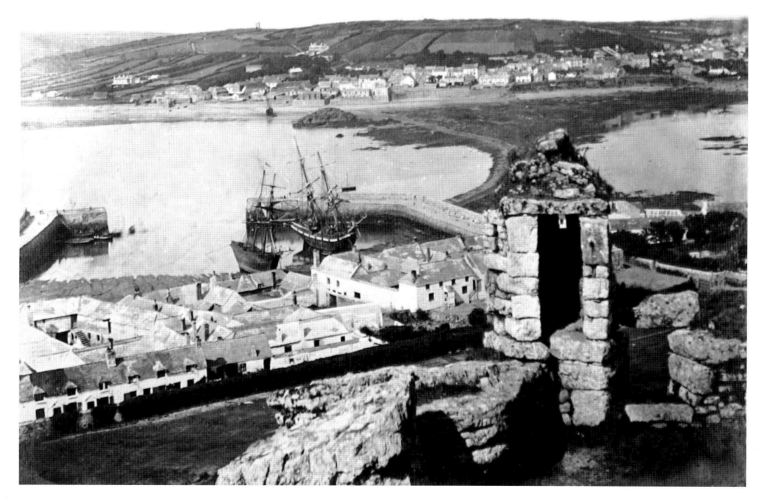

View of Marazion from the Oratory, St Michael's Mount.

Rocks on St Michael's Mount, near the Battery.

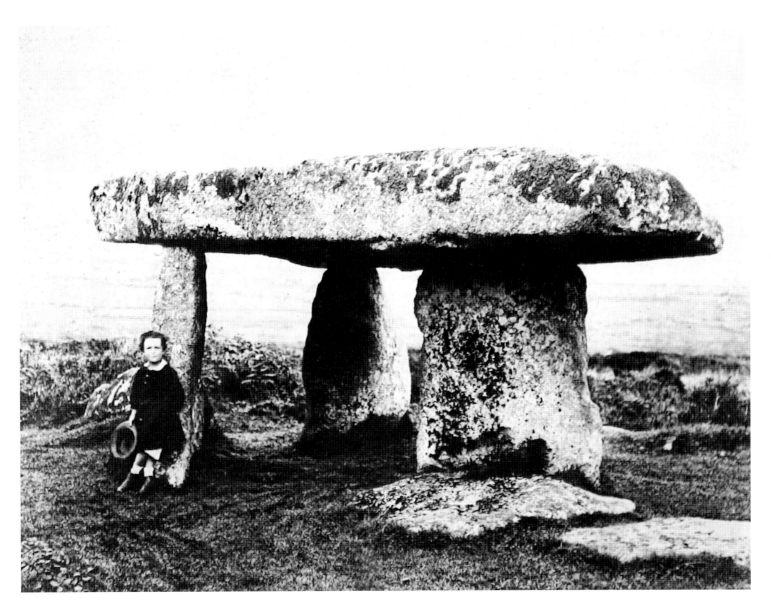

Lanyon Cromlech near Penzance.

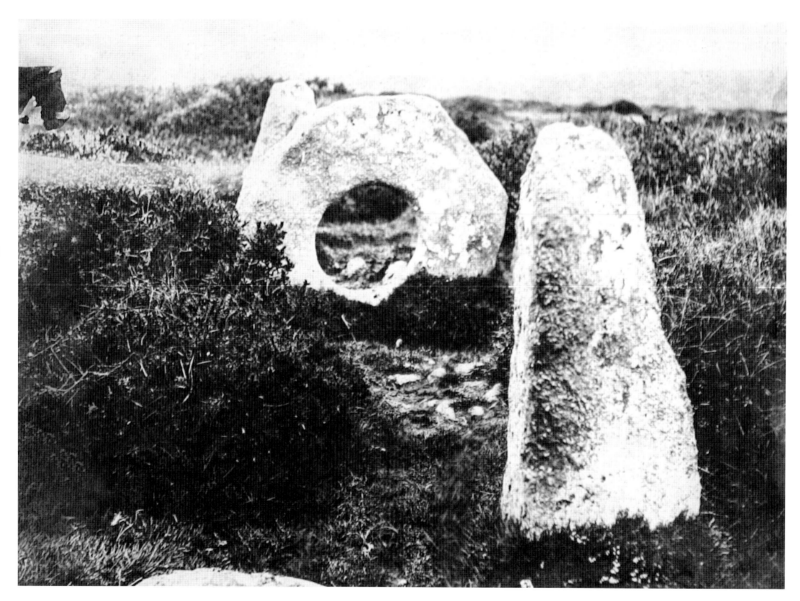

134

The Holed Stone near Penzance.

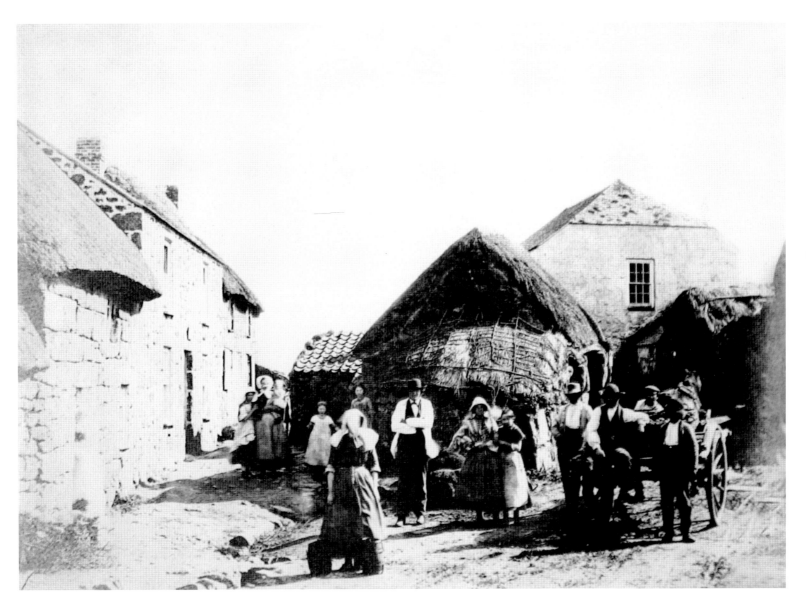

The Logan or Village of Treen.

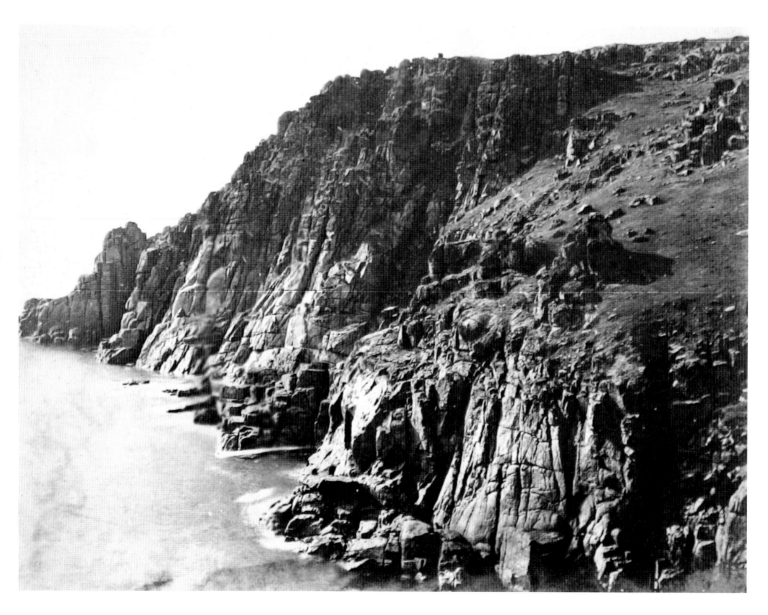

Rocks on Perloe Bay.

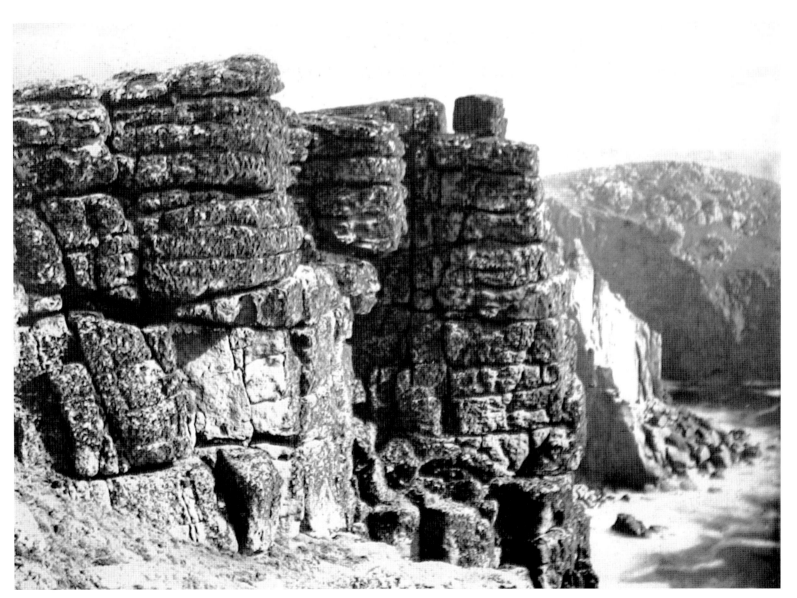

Group of weathered granite rocks, Pardennick.

138

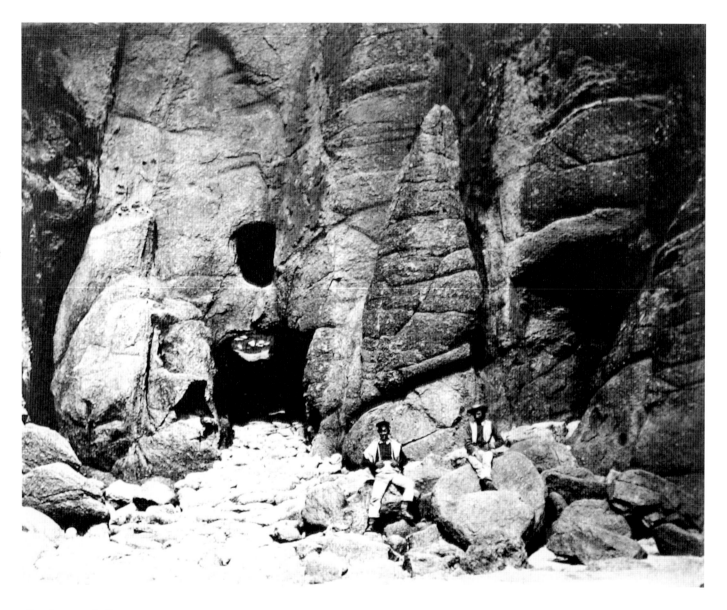

Porthgwarrah Cove.

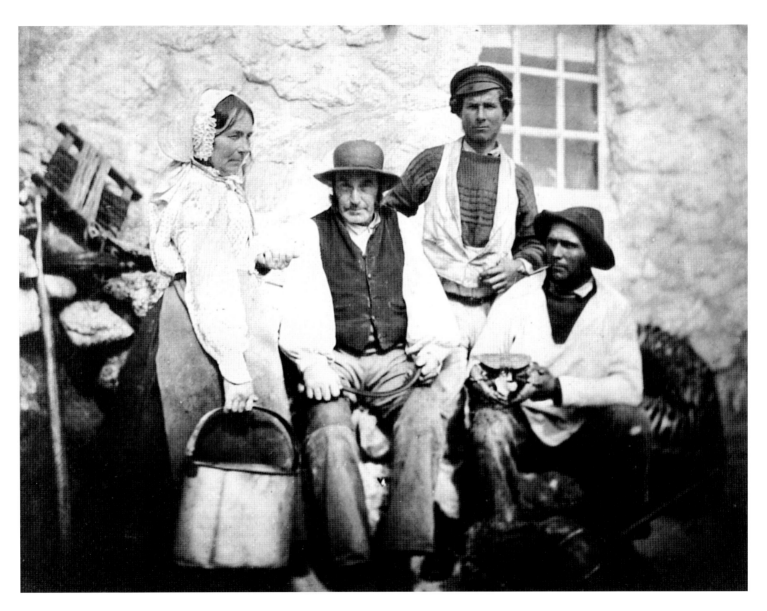

A family group at Porthgwarrah Cove.

Fish boy, Idearn.

Fishermen, Porthgwarrah Cove.

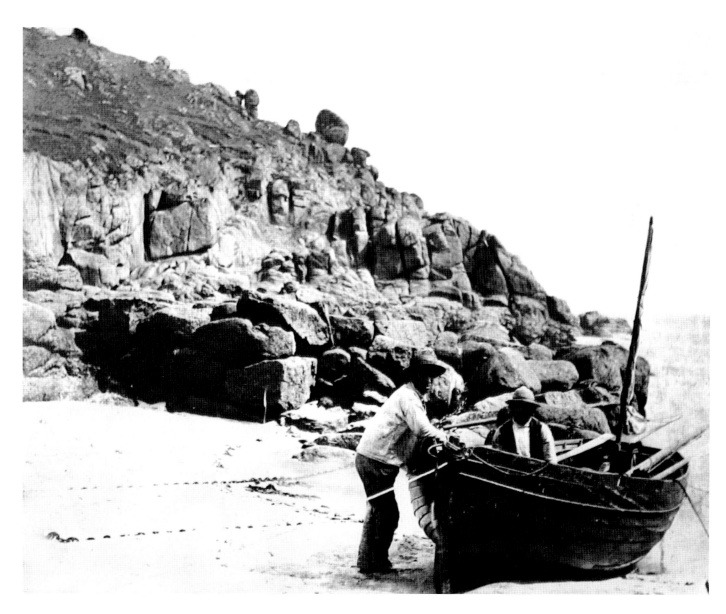

Pilchard fishermen, Porthgwarrah Cove.

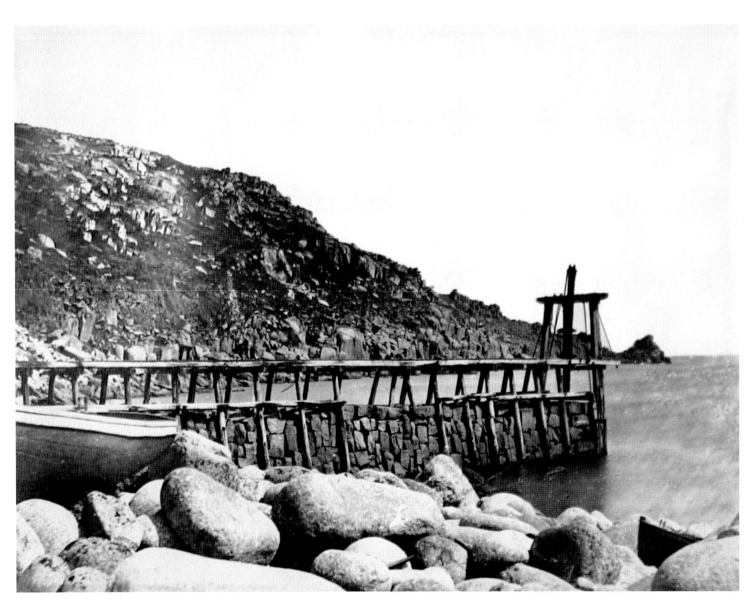

Lamorna Cove and Jetty, granite boulders.

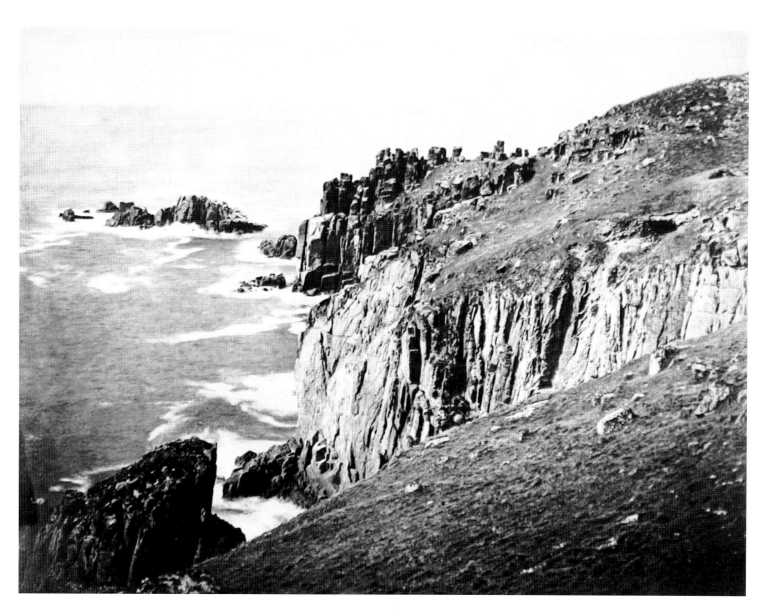

143

The Land's End.

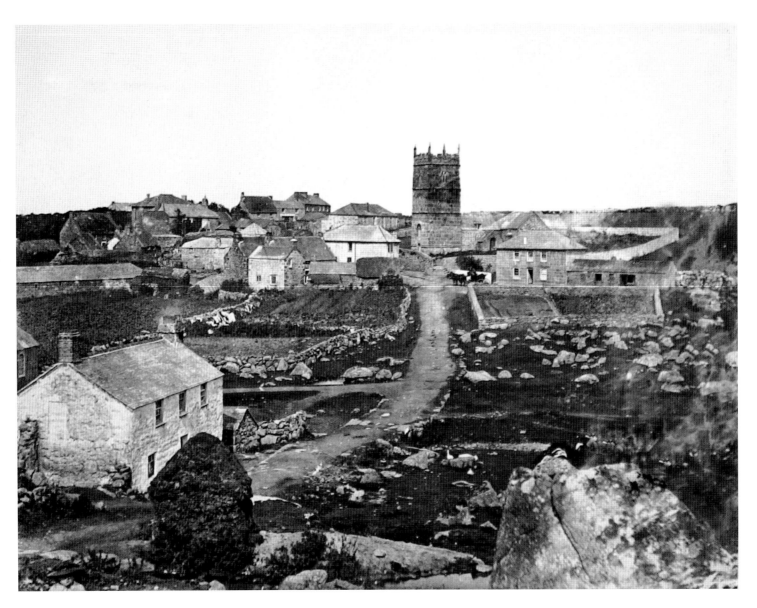

The Church Town of Zennor.

144

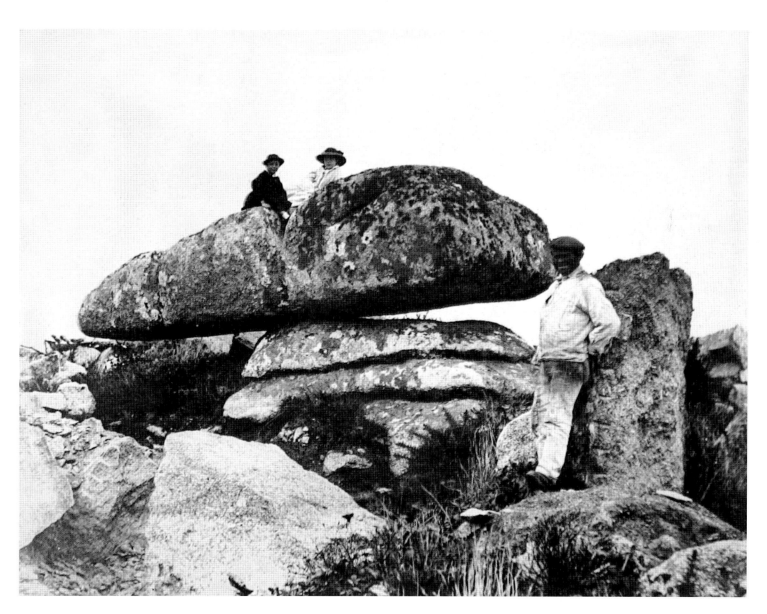

Logan Stone near Zennor Church Town.

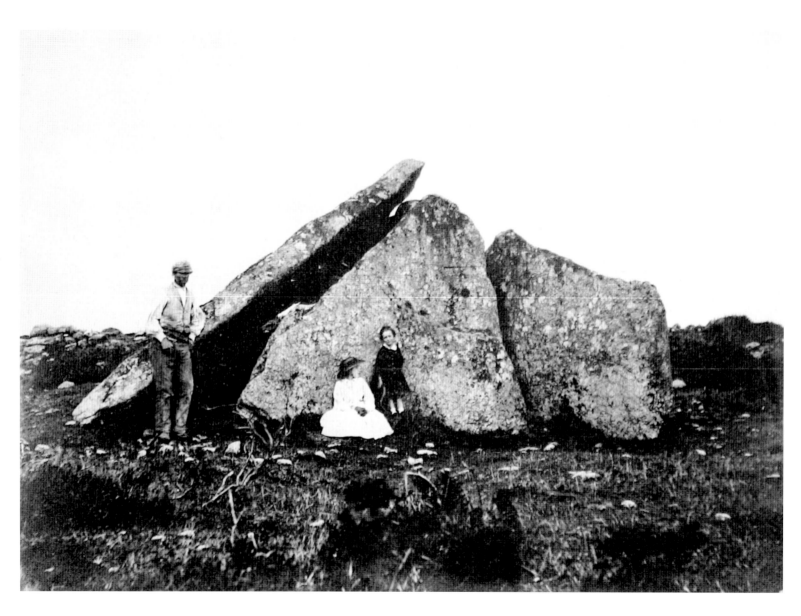

Zennor Quoit.

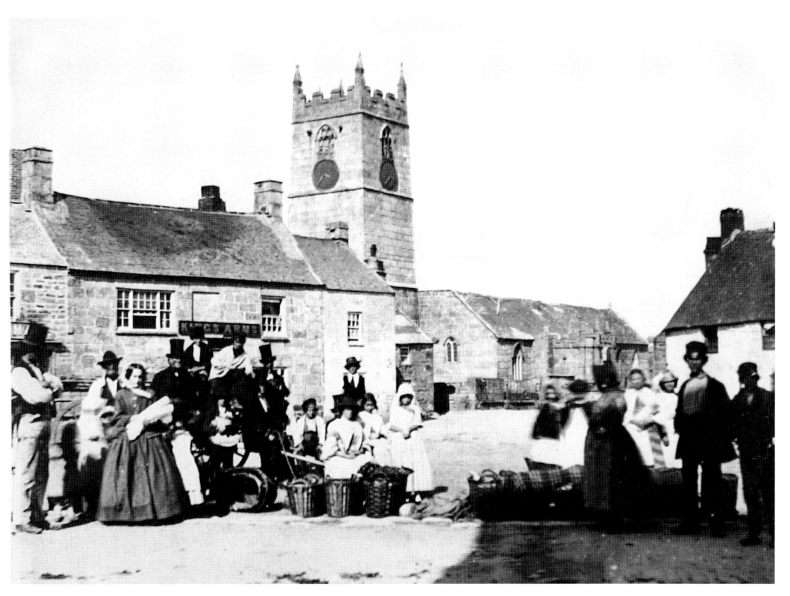

The Church Town of St Just, Market Day.

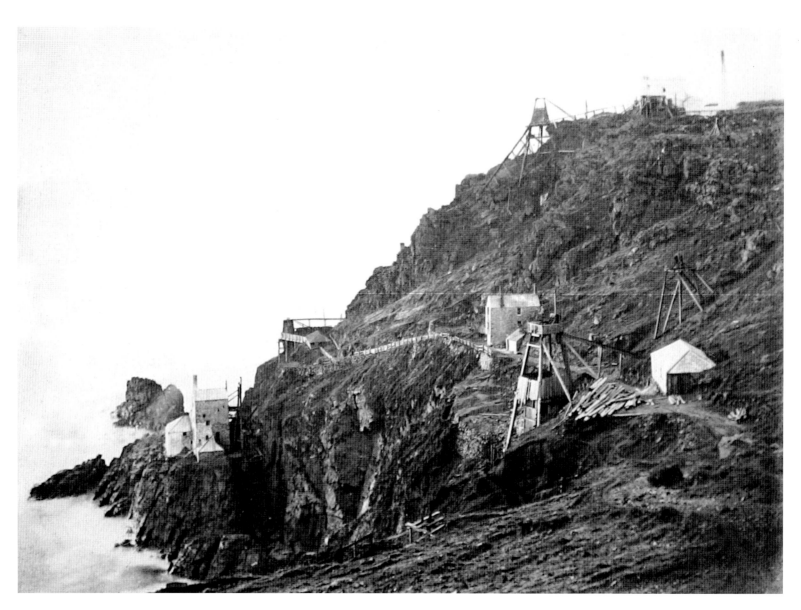

Botallack Mine.

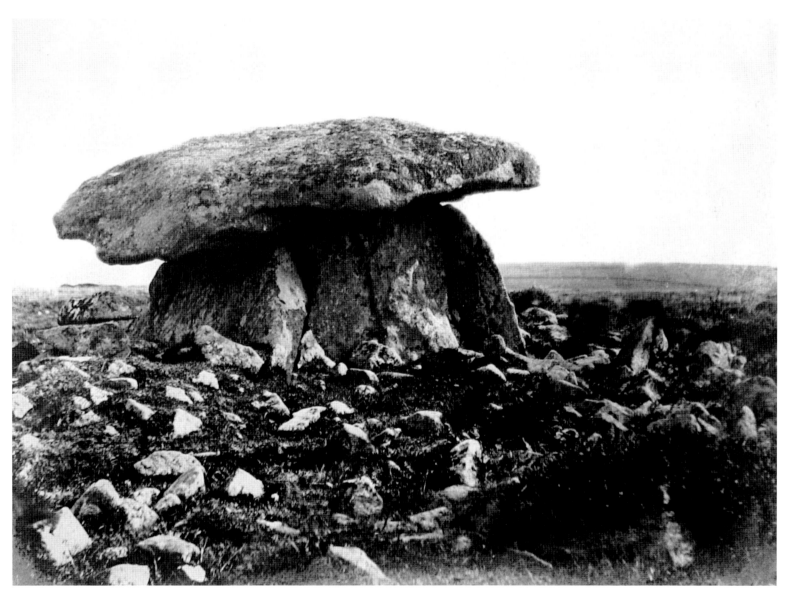

Chun Cromlech, Morvah.

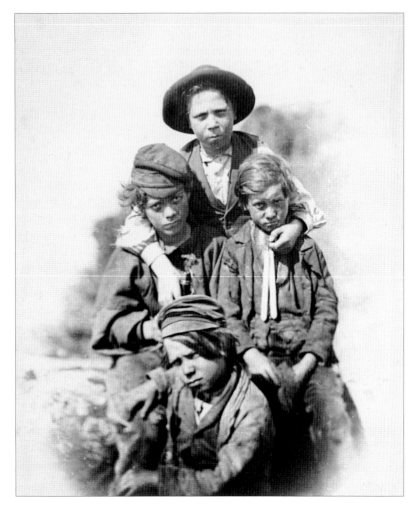

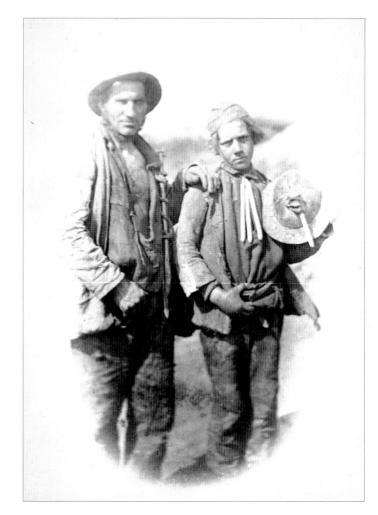

Group of miners at Levant Mine.

Miners at Cain Galva Mine.

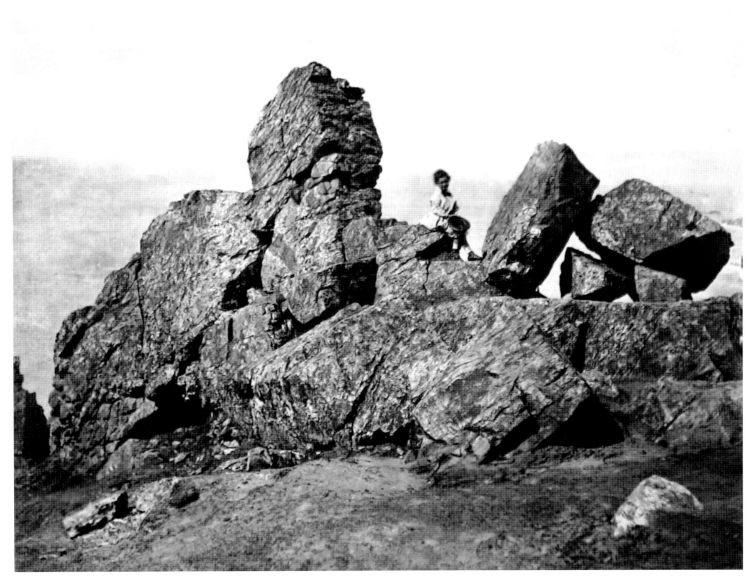

Group of Greenstone Rocks near Levant Mine.

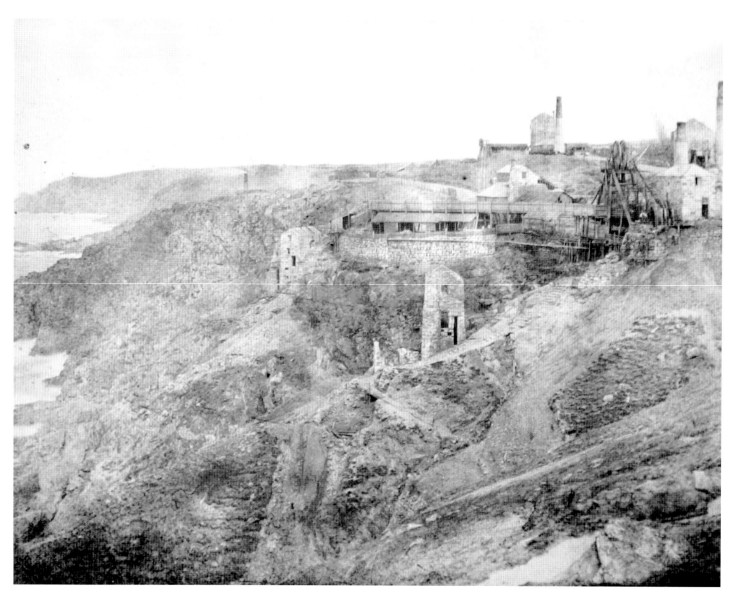

Levant Copper Mine.

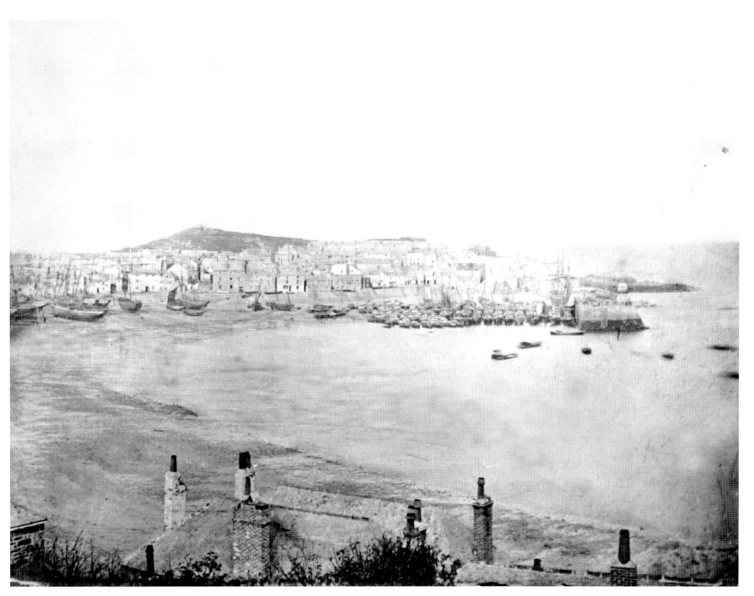

Town and Harbour of St Ives.

The Lake District

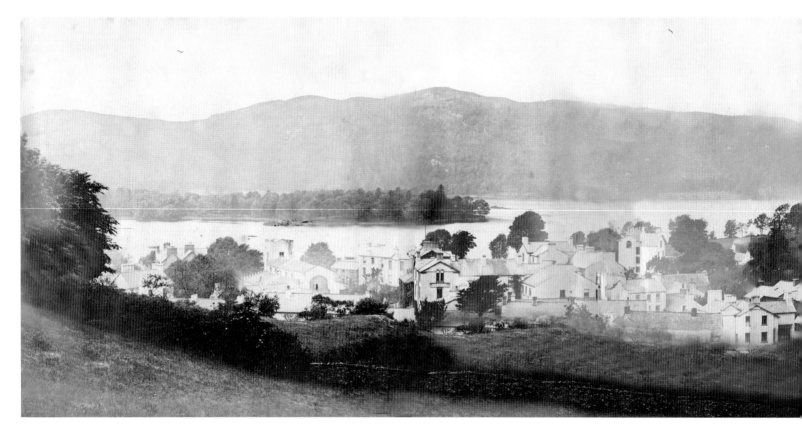

Panoramic view of Bowness from the Victoria Hotel.

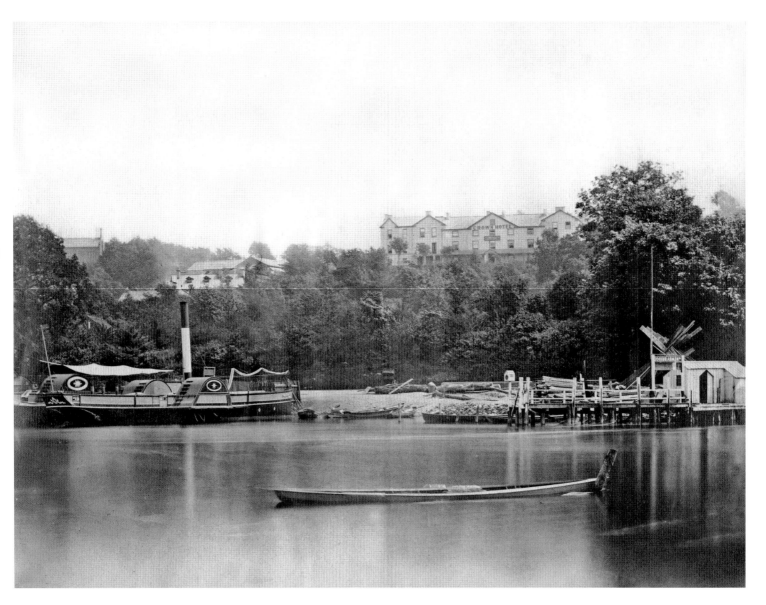

Bowness & the Crown Hotel from near the Steam Packet Pier.

Bowness, Windermere.

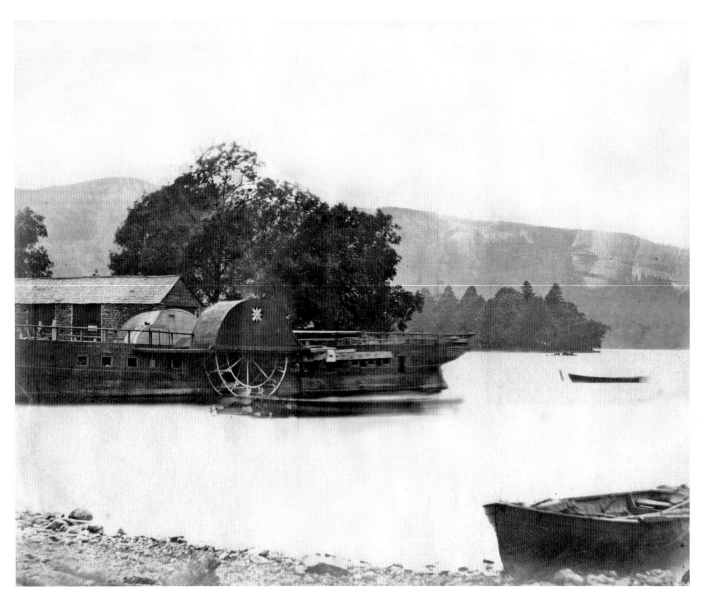

The Lady of the Lake: burnt July 1855.

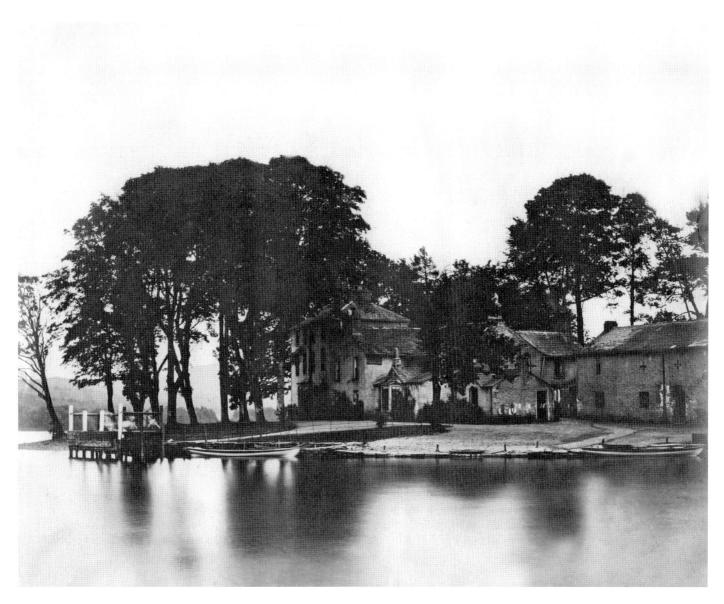

Ferryside, Windermere.

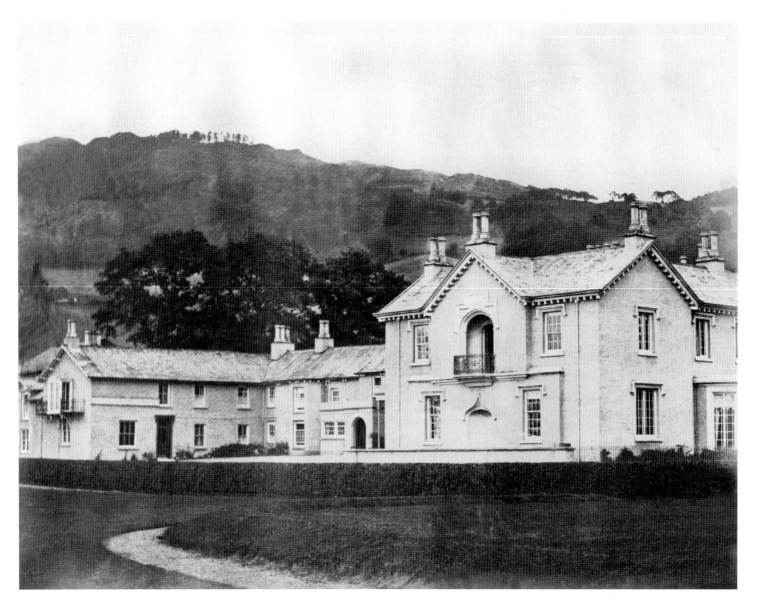

The Inn at Lowood, Windermere.

Wray Castle, Windermere.

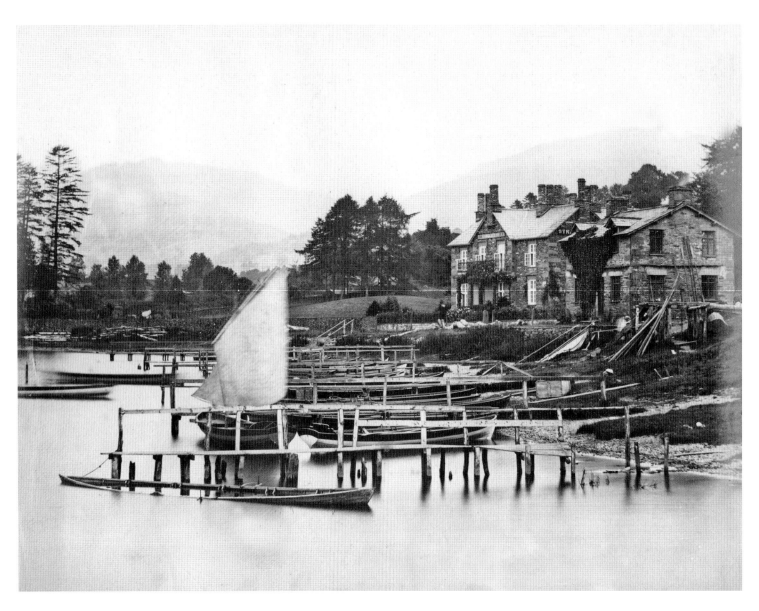

Waterhead, Windermere.

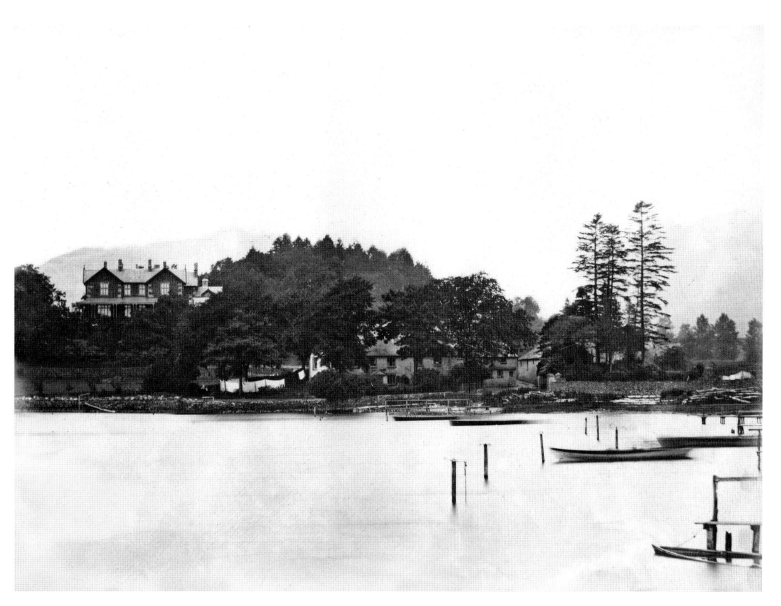

Waterhead, Windermere.

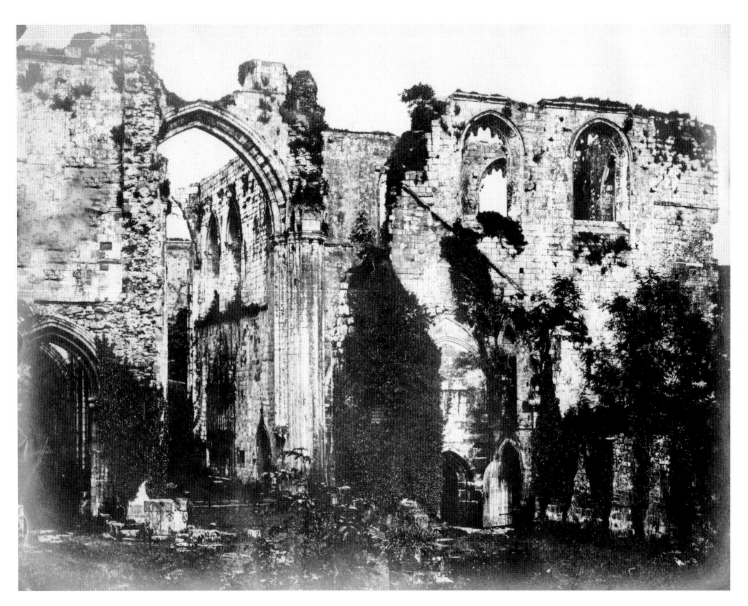

The West Window of Furness Abbey.

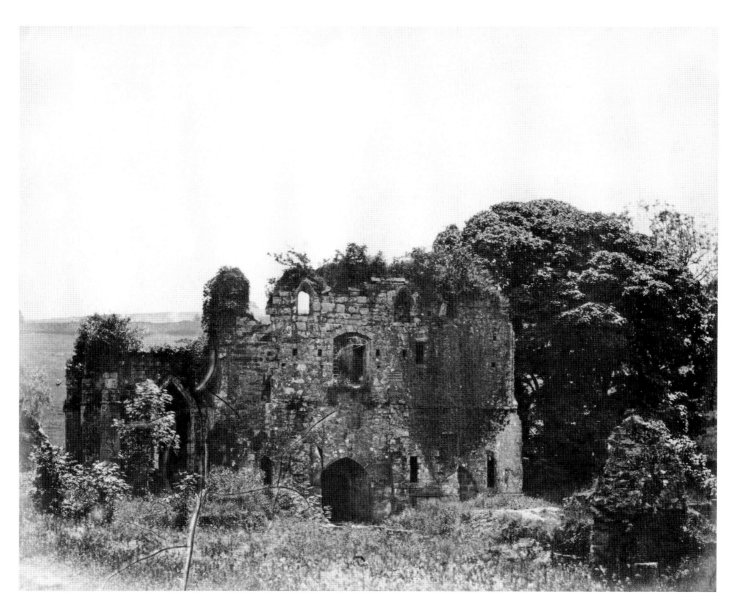

School House of Furness Abbey.

Brown's Lake Hotel, Grasmere.

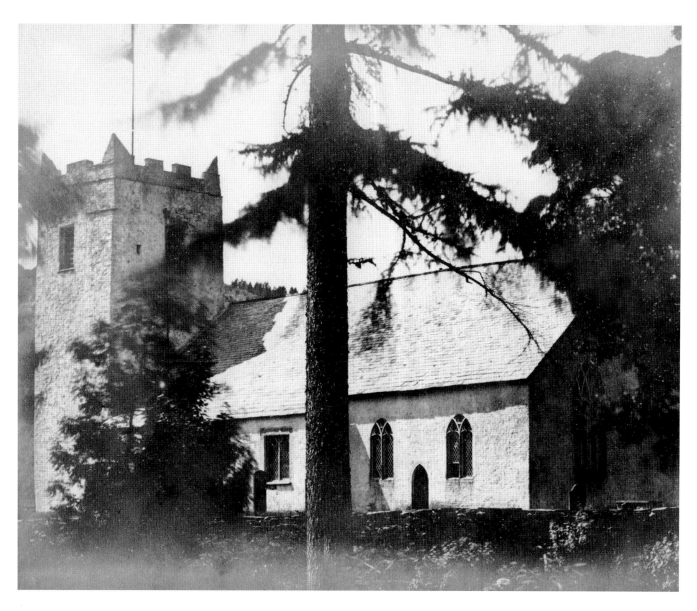

Grasmere Church.

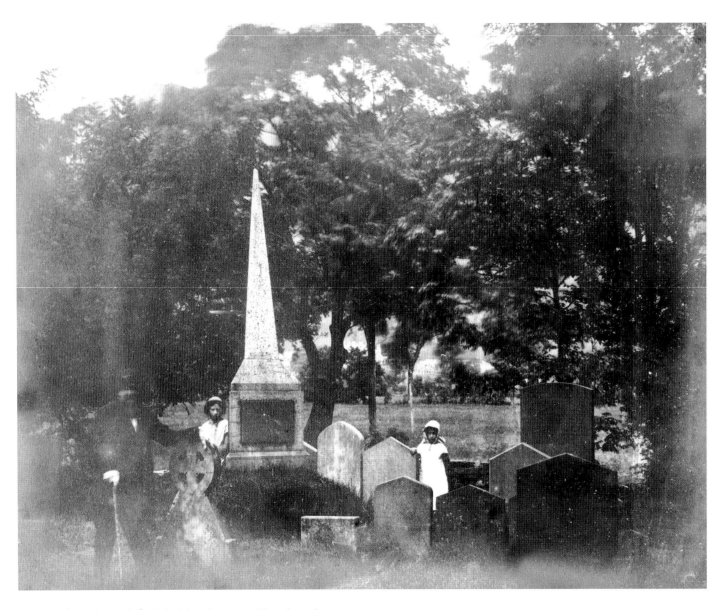

Tombs of Wordsworth & Coleridge, Grasmere Churchyard.

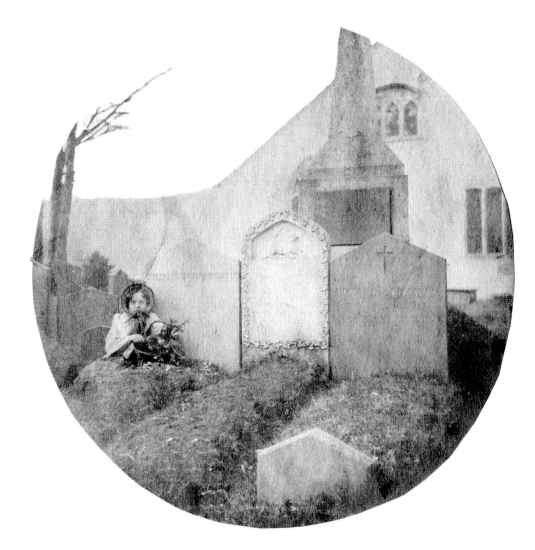

Wordsworth's Tomb, Grasmere Church.

Waterhead Hotel, Coniston.

Boat house on Coniston Lake.

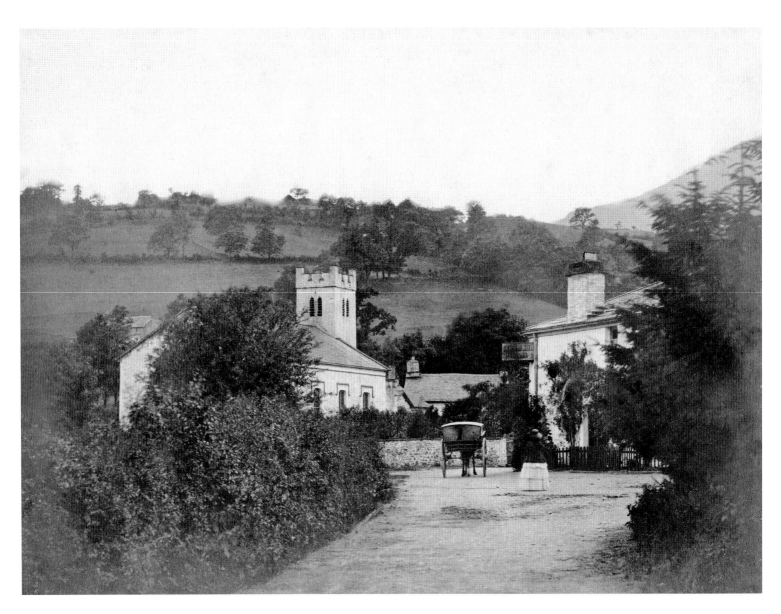

The Church at Coniston.

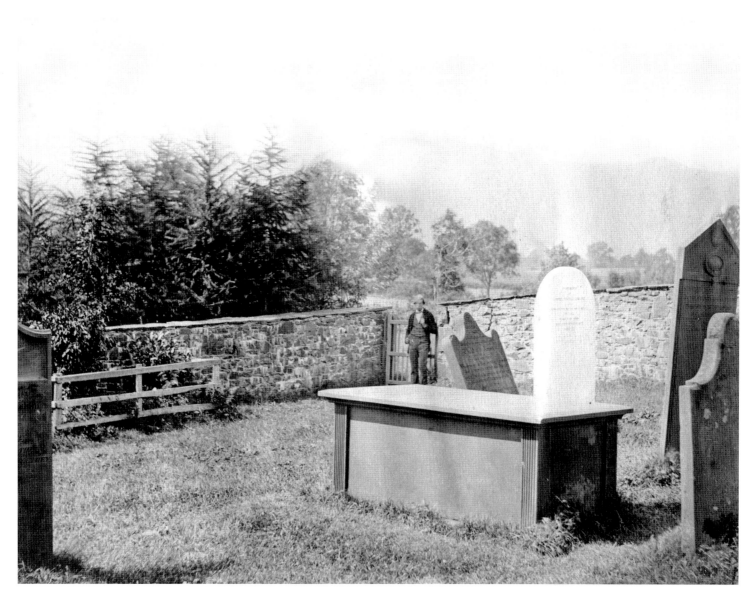

The Tomb of Robert Southey in Crosthwaite Churchyard, Keswick.

Greta Hall, formerly the residence of Southey.

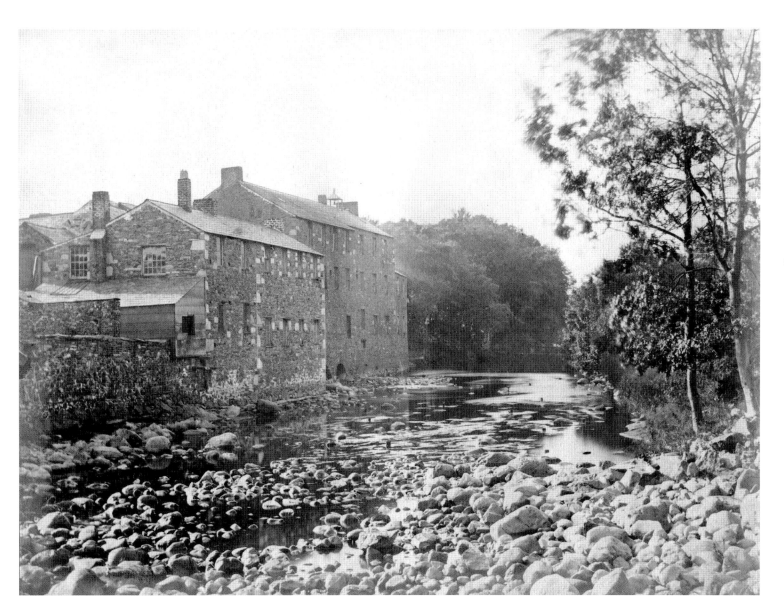

Black lead pencil manufactory, Keswick.

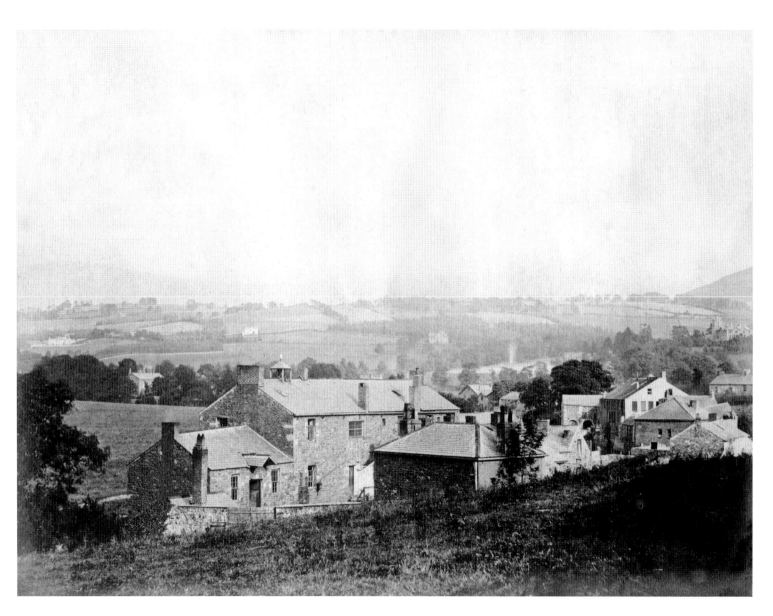

Mr Bankes' pencil manufactory from Greta Hall.

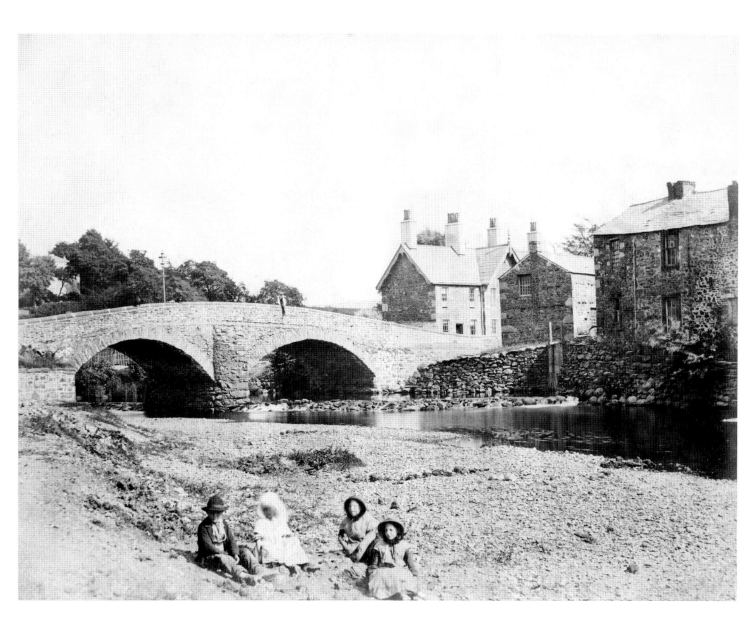

Greta Bridge & Southey's House, Keswick.

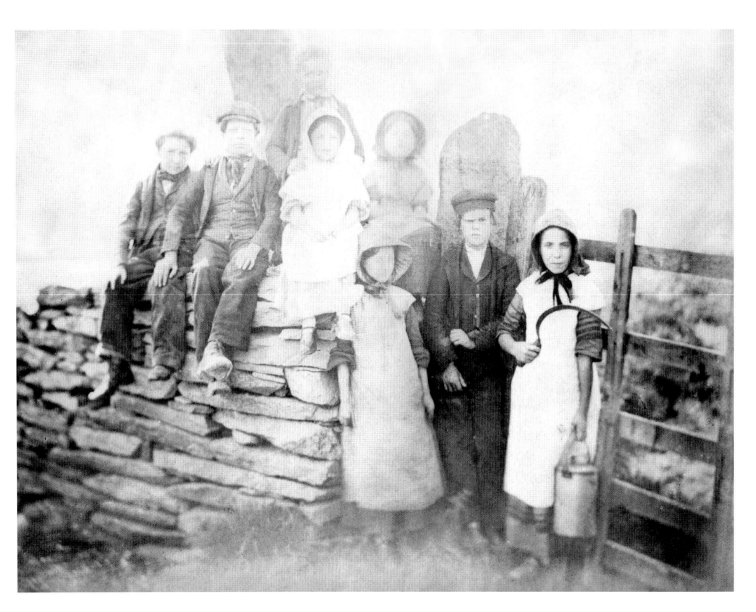

Group of children at Greta Bridge, Keswick.

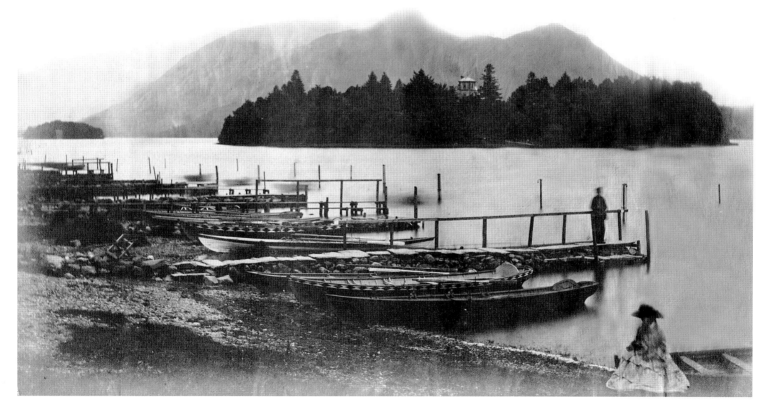

Derwent Water & Derwent Isle, residence of Mr Marshall.

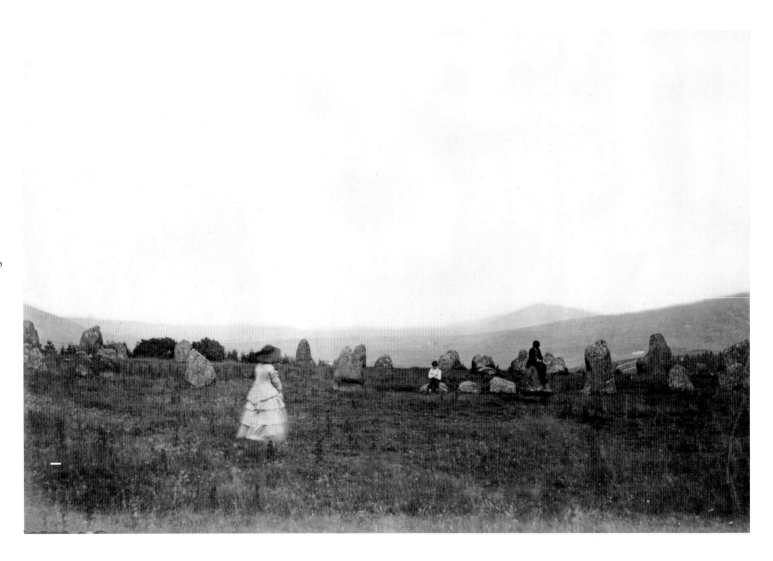

The Druids' Temple, near Keswick.

View from Mrs Dewar's Lodgings, Keswick.

A Tanyard, Keswick.

Smithy & Bridge, Legberthwaite, Cumberland.

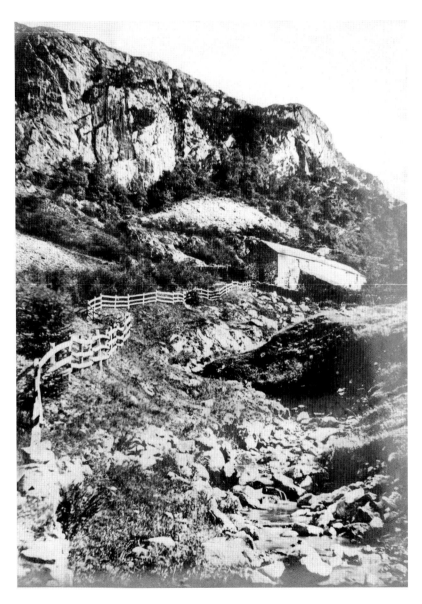

The Castle Rock, Vale of St John's.

Brackenrigg Toll Bar, Bassenthwaite.

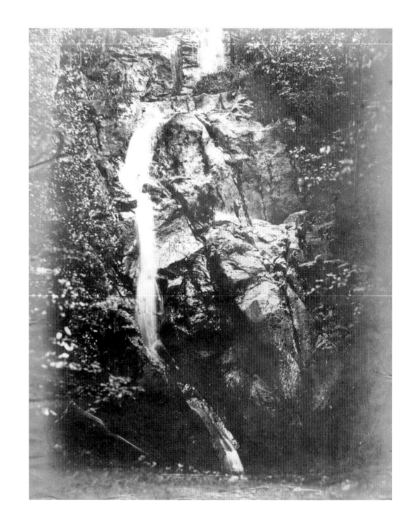

Old Oak, Monks Hall Farm near Keswick.

Waterfall at Bartons, Borrowdale.

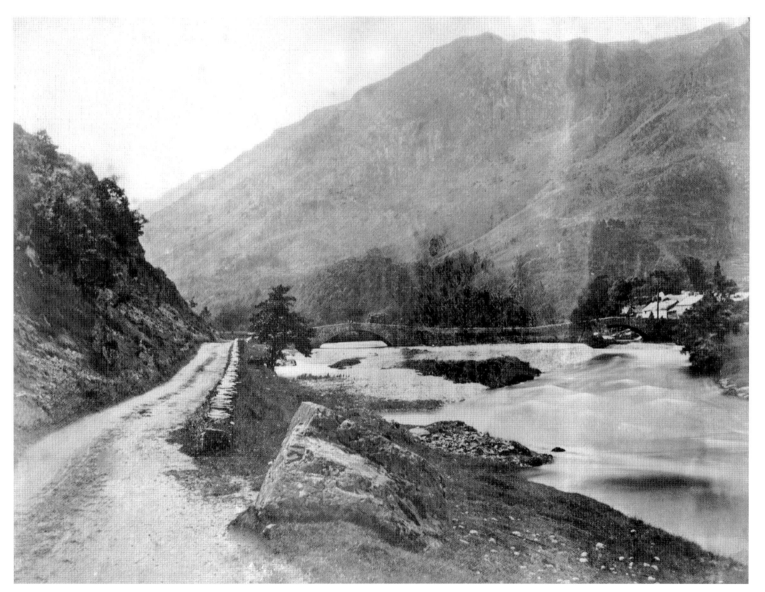

The Grange Bridge, Borrowdale.

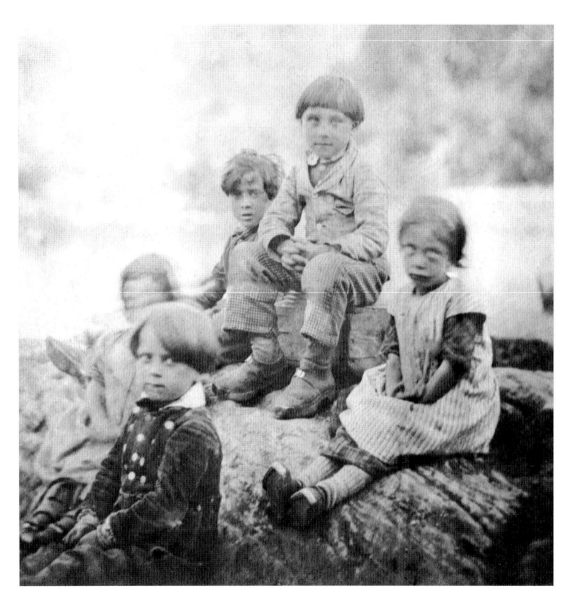

Group of children at Grange Bridge.

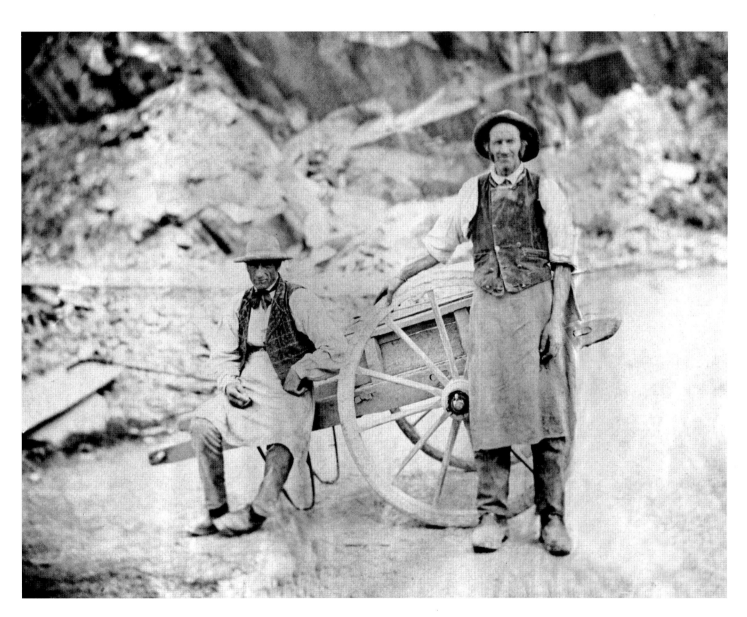

Men in Quay Foot Slate Quarry, Borrowdale.

Bibliography

Gutch's first brief experience of editing a scientific journal was probably with the *Quarterly Journal of Meteorology and Physical Science* in 1842. Gutch then went on to edit the *The Literary and Scientific Register* for fifteen years 1842-1856. This annual journal frequently contained photographic formulae, often compiled by Gutch himself. Following the journal's closure he submitted items related to photographic formulae to the monthly *Photographic Journal* (vol.3, nos. 41, 44 & 49) in 1856. In the late 1850s Gutch frequently corresponded with *Notes and Queries,* a fortnightly journal that acted as a kind of Victorian gentleman's Internet chat room.

In 1854 JWGG published *Londina Illustrata: An Index to a Collection of Prints and Views Illustrative of London Topography.*

Many of the references used throughout this present volume have been taken from Thomas Sutton's fortnightly *Photographic Notes.*

Gutch wrote two essays for the Jersey-based journal; both appeared in four-parts during 1858-59:

Recollections And Jottings Of A Photographic Tour, Undertaken During The Years 1856-7.

 Part 1: vol. 3, no.51 (15 May 1858)
 Part 2: vol. 3, no.52 (1 June 1858)
 Part 3: vol. 3, no.53 (15 June 1858)
 Part 4: vol. 3, no.60 (1 October 1858)

Positive Pictures Taken From The Camera Of A Peripatetic Photographer In Search Of Health And The Picturesque. 1859.

 Part 1: vol. 4, no. 76 (1 June 1859)
 Part 2: vol. 4, no. 78 (1 July 1859)
 Part 3: vol. 4, no. 87 (15 November 1859)
 Part 4: vol. 4, no. 88 (1 December 1859)

'Recollections' describes Gutch's thoughts and experiences during his travels in Scotland and The Lake District. 'Positive Pictures' largely concentrates both on his enjoyable experiences in Cornwall and the often less than happy times he spent whilst attempting to portray all the churches in Gloucestershire.

Julian Cox cites Gutch extensively in his doctoral thesis: *From Swansea to the Menai Straits; Towards a history of photography in Wales c. 1840-1860.* University College of Wales, Aberystwyth. February 1990.

Gutch has been rarely mentioned in recent photographic literature, although a good essay by David Wooters entitled 'In Search of Health and the Picturesque' appeared in the 1993 spring / summer edition of *Image* (vol.36, nos.1-2). Wooters concentrates on Gutch's visit to Scotland in 1857 with illustrations drawn from the album, *Photographic Illustrations of Scotland.*

Other published sources

Vaughan, William. *Romantic Art.* London: Thames and Hudson. 1978.

Thomas, Charles. *Views and Likenesses. Photographers and their work in Cornwall and Scilly 1839-70.* Truro: Royal Institution of Cornwall. 1988.

Bartram, Michael. *The Pre-Raphaelite Camera. Aspects of Victorian Photography.* London: Weidenfeld and Nicolson. 1985.

Taylor, Roger & Schaaf, Larry J. *Impressed by Light. British Photographs from Paper Negatives 1840-1860.* New York. The Metropolitan Museum of Art. 2007.

Index

Plate owners